Village Elders

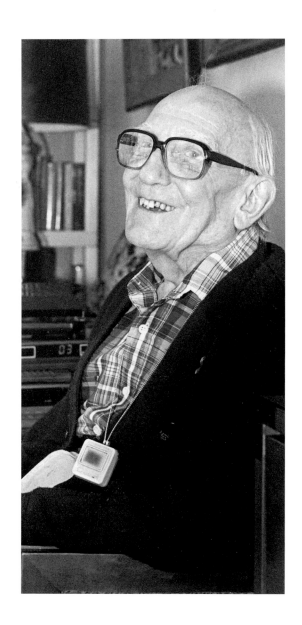

Village Elders

Penny Coleman

University of Illinois Press

Urbana and Chicago

Library of Congress Cataloging-in-Publication Data
Coleman, Penny.
Village elders / Penny Coleman.
p. cm.
Includes bibliographical references and index.
ISBN 0-252-02552-0 (cloth : alk. paper)
1. Aged lesbians—New York (State)—New York—Case studies.
2. Aged gay men—New York (State)—New York—Case studies.
I. Title.
HQ75.6.U52N73 2000
305.26—dc21 99-050549

C 5 4 3 2 1

For the tenacious love
with which we have muddled through,
the life we have built together,
and the optimism and joy
with which I anticipate
the years to come,
this book is dedicated
to my children,
Charlie and Sophie,
to my love, Elana,
and to Village Elders everywhere.

And in such loving memory, to Howard and Donald

I found myself thinking that telling the truth—your side of it anyway, knowing that there were truths other than your own—was a moral act, a courageous act, an act of rebellion that would encourage other such acts.

—*Dorothy Allison*

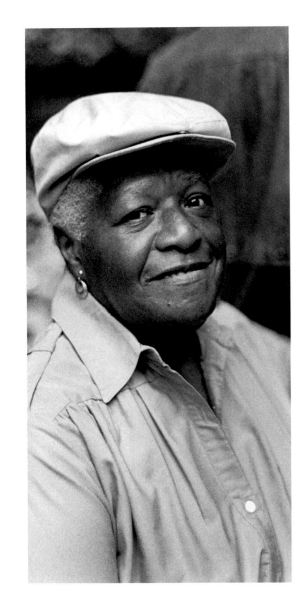

Contents

Prologue

It is June again and I am watching my children watching me watching the Parade. It is, in some very real sense, our first. Certainly it is not the first time we have gone. In the past it has been a shared delight, New York's best public theater. But this year is different for all of us. We are all changed.

They are feeling betrayed. They thought they knew me. I was their mama. Now I am different—familiar, but different. I am in love with a woman. She isn't with us. They are still too upset by her presence in our lives—not because she is a woman but because she embodies the possibility of abandonment and more change than they want to entertain. They have asked if that makes me a lesbian.

I am unsure how to answer. The politics fit comfortably. It is a minority status I would be proud to claim. But it is also a box, a label, and I am not altogether sure what will be expected of me if I wear it in public. They are looking for a clarity I can't give them. I watch them watching the most conservative alongside the most flamboyant. I know they are wondering which I will grow up to be. They are wondering where my transformation will end, if they will still know me, and how they will manage to tell their friends. We are on a multitude of cusps. They are watching and wondering, and so am I.

Then the SAGE bus appears. Excitement rolls down the block with it. As it passes, everyone in the crowd responds. It is a hero's welcome, white heads atop the platform, hands clutched and raised in victory salutes, honoring the honor and mirroring the enthusiasm. These are our elders, those who have made it. At this tentative and fragile moment in my own new love I am looking for the possibility of a future. In the lives and the learning of these old people I imagine I might find the map, or a map. And, if not a map, well, perhaps, inspired by their stories, on the energy of that inspiration and my own hunger, I might be able to piece together a possibility.

Acknowledgments

Without the help of SAGE, this project would not have been possible. SAGE (Senior Action in a Gay Environment) is the nation's oldest, largest, and most respected organization serving the lesbian and gay elderly. For over twenty years, it has developed vital community services and programs that support the senior lesbian and gay community in New York City and nationwide.

SAGE opened and runs New York City's first lesbian and gay drop-in center and was instrumental in establishing and providing supervision for a second in Queens. SAGE's "AIDS and the Elderly" program is the only program in New York City specifically designed to meet the unique needs of seniors affected with HIV/AIDS. SAGE also offers a variety of group support and socialization opportunities, and provides individual and group counseling, social services, "friendly visiting," and case management for homebound seniors. In addition, SAGE educates professionals, the media, lesbian and gay people, and the nongay public about the unique challenges of aging as a lesbian or gay man.

Recognized nationally as a model of service delivery for community-based social services, SAGE has established affiliates throughout the United States and Canada. SAGE-Net affliates are located in a number of areas,

including Boston, Mass., Fort Lauderdale, Fla., Milwaukee, Wis., Minneap-olis, Minn., Portland, Ore., Providence, R.I., and Syracuse, N.Y.

For more information about SAGE or SAGE-Net affiliates, programs and services, or starting a SAGE-Net affiliate in your area, please contact SAGE at 212-741-2247.

As an organization, SAGE lent me its credibility, its support, and, most importantly, the wit and wisdom of its members. I am so very grateful for all I have learned from them. Special thanks go to Jim Lomax, my dear friend, mentor, and most trusted advocate; and to his dear partner, Jeff Allison. I always want them on my team, whatever the game. To Arlene Kochman, former executive director of SAGE, who first opened that door to me, and to Terry Kaelber, SAGE's current executive director, who has helped me define, direct, and finance this project and who, in the process, taught me to take myself seriously; to Martin Wendell, Sandy Kern, Cara Palladino, and Susan Levine for their ideas, referrals, and constant atten-tion to detail; and to Nicolai Gioscia M.D. and Anthony LaRocco, James Lomax M.D. and Jeff Allison, Morty Newburgh and Michael Crisafull, Charles Gandee, Antonio Hidalgo and Jeffrey Kassell, Doug McClure and George Blomme for their most generous financial support.

Heartfelt thanks always to Sheila Okin, who has cherished me and my stories; to Carole Gallagher and Pam Parlapiano, whose stubborn idealism has always inspired me; to Heather Driscoll, who brainstormed and de-signed and transcribed and wanted to be along for the ride, even when it wasn't much fun; and to Stacey Cushman, who was usually there for the not-much-fun parts, and brightened them immeasurably. To Linda Cole-man and Virginia Reath, who gave me the right words and wine at the right times; to Roland LeBlanc and David Williams, bless them both, for all the thoughts, and insights, and hours shared; to Ken Wittenberg, whose infallible eyes I rely on; and to Evan Wittenberg, Susan Coleman

Acknowledgments

and Peter Bynum, Linda Bradley, Alan Jones, and Morgan Bradley-Jones, who always showed up for me, and to Payson Coleman, whose loyalty is a gift. To Erica Duncan, who first gave me the tools to sort and write these stories; to Pat Hollahan, Cope Cumpston, and especially Richard Wentworth and David Perkins at the University of Illinois Press, whose indulgence and enthusiasm made it real. To my children, Charlie and Sophie, for the courage, grace, and loyalty with which they have stood by me. In some ways, the journey has been harder for them than it was for me. I am so very proud of them. And always and overwhelmingly, to Elana Michelson, who, with infinite patience, exquisite intelligence, and merciless good taste, read (and reread), listened, mirrored, edited, organized, soothed, and believed. May we, laughing, and still this much in love, grow old together.

Introduction

The day I showed up at Gerry's house to show her what I had written about her, she was feeling uncharacteristically depressed. "This morning was bad," she said. "I had a hard time getting out of bed." Gerry is ninety-two, but the frailty of her body is rarely evidenced in what comes out of her mouth. "Aw, shame, Gerry," I cajoled. "You're just having a bad day. Forget to take your Prozac?" "No, seriously," she insisted, "I'm afraid they're going to put me away. They're going to put me in a home." And then with the humor I have come to expect, "You tell me, how'm I going to get my vibrator into a home? In a brown paper bag?" "Oh, Gerry," I said, "that's the good news."

And that, I think, is precisely what this book is really about: the good news. In saying that, I do not mean to dismiss the very real aches and pains, the fears and endless losses that aging inevitably brings. But in collecting this material I was made privy to vitality and desire and courage and loyalty that I never expected to find. Our culture may erase images of the aged, especially those who are labeled gender outlaws; women, people of color, and those of limited means are even further marginalized. But the lives I was privileged to intersect have taught me much, not just about the history of a community but about complexities of gender and the

richness of age. I now have far less reason to fear. Each one of these gloriously unique human beings gave me something precious. They gave me their wondrous faces, each etched with lived history. They gave me stories and insights and attitude. They gave me inspiration.

Things were different when they were growing up. They were schooled to caution, and with few exceptions, there was little to distinguish caution and discretion from closeting. Homosexuality was still classified as an illness. Even the civil rights protections that we find so shamefully inadequate today were nonexistent. There were no support groups, no community centers, and always the threat of arrest, job loss, eviction, exposure. There were legally enforced dress codes. There was no shared ownership or inheritance. There were no death benefits, and there was no legitimized time to mourn. Yet, in spite of the climate of the times, in spite of real and omnipresent dangers, they found ways to survive with their souls intact. I want to honor their warrior hearts and their insistent and courageous claims to selfhood. As Stormé says, "I am who I am." Such a simple statement, and yet a profoundly radical one in a society that exacts conformity, that posits ideals of behavior, appearance, and desire that make us all feel anxious, inadequate, and afraid.

I did not set out to construct a community history. I was interested in portraiture, both visual and verbal, the visceral flesh and warmth of personal histories. I was not even particularly interested in the accuracy of my subject's memories, but in their quality and texture, what they revealed about their lives, their concerns, their relationships, and their feelings about aging. I imagined it more as a family album, with real and accessible grandparents, Elders, who courageously opted for grace instead of desperation, and who wanted to share who they have been and what they know.

I have called this project *Village Elders* because my subjects are New Yorkers and New York's Greenwich Village has been an actual or symbolic

home to many of them. The Village community has traditionally tolerated, even embraced and celebrated, those whose beliefs, behaviors, and desires fall outside of the mainstream. And Greenwich Village was, of course, the site of the famous Stonewall uprising in June of 1969, which altered the political and social landscape for gender outlaws of all stripes. These are indeed the Elders of that community, who, often in spite of themselves, have lived richly revolutionary and heroic lives. Their efforts to establish physical and emotional sanctuaries in a society that labeled them sick and aberrant were the foundation for the political movements that others have taken up.

◆ ◆ ◆

I have been a photographer for thirty years. I have learned to respect the power of an image to communicate truth, and its commensurate power to misrepresent. These Elders have as well. Many were initially anxious about participating. They understood that, however inadvertently, I might do real harm. For many, perhaps most, it was the first time they had told their stories, and it was not unlike a "coming out." They opted to take the risk because they agreed that visibility was a critical step in challenging the fear and ignorance that feed intolerance. In anticipation of their well-founded apprehension, I built a number of reassurances into my process.

I let people choose their own pictures and gave them editorial control over the words. I did not ask for releases until the work was done and they were satisfied that they had been fairly represented. I had strong misgivings about structuring my process in such a way. I imagined being in thrall to propriety, to egotism, and to superficiality. Quite the opposite turned out to be true. The more precisely I mirrored their reality, regardless of how transgressive or astonishingly intimate it sounded to me, the more inclined they were to nod and say, "Yes, that's true." Anything that didn't

look right, or sound right, or feel right, ended up on the cutting room floor. I lost some images that I would have loved to have used, what I thought were some elegant turns of phrase, and some wonderful stories. But what emerged, in every case, was a collaboration of which we are both proud.

My friend Jim Lomax likes to remind me that a death is like a library burning down. Two libraries have burned since I began. Donald, who masked sweetness with opinions, bravado, and a curmudgeon's dogmatism, and Howard, whose sweetness couldn't be masked or contained, slid away from us. Much of who they were and what they did lives in the memories of those who loved them. I am honored to be able to share some of what I was given, in however painfully abbreviated form. I will always miss them. I hope their portraits, and the rest in this book, will be the gift to others that they have been to me.

Village Elders

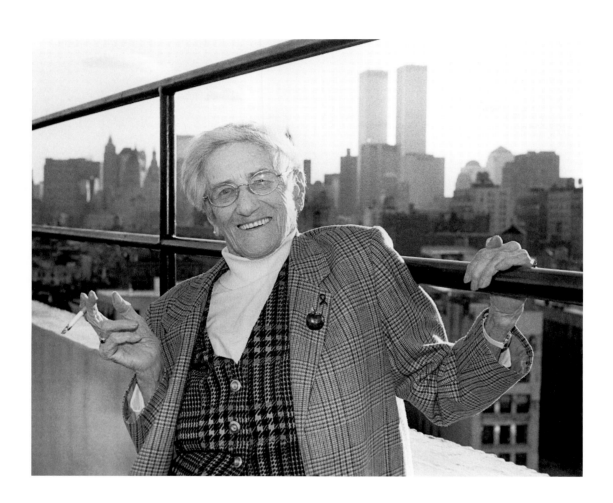

Gerry

Gerry leans back in her chair, stretches languidly, and takes a long drag from an ever-present cigarette. She pats her sheaf of poems, elegant, wreathed in smoke, inhaling the sweet silence that hangs over a deftly delivered final stanza. She tilts her chin, offers a strong profile, eyes focused on the beyond. I am being treated to Radclyffe Hall channeling Dorothy Parker, and it is a masterful performance.

Gerry is languid only for effect. More often it is her spring-wound hunger that shows. "Sex, love, companionship, recognition, they're the price of my old age. It's a damned shame. I'm alive. I'm vibrant. I'm romantic. But there's no one left to call me up and say, 'Gerry, I've got nothing to do. How about a movie?' I just wish I had more time to benefit from the mistakes I made."

This is a woman who likes words and conversation, but we have been at this for a while now and she is, after all, ninety-two. I ask her if she is perhaps getting tired. "Are you out of your mind? I never get tired talking about myself. That's my hobby!" Three years ago she was feeling her age. Now she takes Vitamins A, B, C, D, E, Zinc, and Cat's Claw but "what's probably keeping me alive is Prozac." The vitamins keep her walking, and the Prozac keeps her wanting to.

So, this is a story that starts a long time ago, back when Borough Park, Brooklyn, was mostly small Italian farms and a scattering of more recent Jewish immigrants. Among them was a Polish Jewish house painter, Jacob Minsky, who spoke broken English but signed his name with all the elegant flourish of a proud and educated man. His wife was illiterate, if fruitful. Gerry was one of eight children. "We weren't rich, but we didn't know we were poor."

One of Gerry's first memories is sneaking under a fence to eat tomatoes. "The Italian farmer caught us. We thought he was going to kill us. We were raised in prejudice. Instead, he said, 'All right children, eat, eat, but don't take.'" She remembers community bonfires in the parks where the kids roasted potatoes in the ashes. They called them "mickies," and Gerry says it is only recently that she realized that the term was a slur. "A Mick is an Irish. It was history, and it wasn't ancient history, yet."

Gerry's parents didn't notice when she dropped out of high school after the first semester. Her older sister had a job and money that she coveted, and "Erasmus Hall in Flatbush was full of rich kids. I used to see my fellow students in the ice cream parlor eating lunch. Asparagus tips on toast and an ice cream soda. I wanted to get a job. I wanted to eat asparagus tips on toast." Asparagus tips on toast—she spits out those consonants with disdain. Childish aspirations. Once she got out of Borough Park, she set her sights on more lofty goals.

In the meantime, dressing in her brother's clothes was a favorite game. She remembers escorting her friend Sid on a stroll down Ocean Parkway in short pants, a cap, and an old jacket of her uncle's. The deception was scary, thrilling. But a practiced artifice, and a habit of reading everything she could find, were all she had going for her when she went to look for a job. She parlayed those skills into a series of positions that required experience and credentials she simply invented. Even an

unsuccessful marriage that left her with two children hardly slowed her down. She was a consummate survivor, always just one step ahead, and she loved the danger of the masquerade.

It seems somehow appropriately in keeping with Gerry's sense of style that the first homosexual she remembers meeting was James Baldwin. Her daughter introduced them. "Marilyn had lunch with Jimmy in the Woodstock restaurant where she worked as a waitress. The next day her boss told her, 'You can't work here anymore. We don't want anybody working here who's going to run around with people like that.'" Gerry was appalled by the racism, but she had other concerns. "He was the ugliest little boy. I said, 'Black, shmack, Marilyn, at least a little better looking.' We didn't know he could write then. He was very young. He was twenty and he had just come up from Harlem. He was telling us he was a writer, he was going to write. Nobody believed him at all."

And then there were the two women she saw walking together down her street holding hands. She found them both exotic and fascinating. "I said to myself, 'Oh, they're lesbians!' You know, that word, Lesbian, you only said it to yourself. You never said it out loud." She followed them to the Seahorse Bar in a secondhand mink coat and ordered herself a boilermaker. Someone else sent her over a second. "I'm wearing my mink coat and she's wearing tight dungarees. You could see her crotch! You could see her bulge! I mean, it was almost offensive the way she looked in those pants! She's very attractive, except I couldn't stand those pants. I never saw a woman in pants like those. We went home and we made love. The very first night I ever touched a woman, I said to myself, 'That's what was missing.' I had an orgasm for the first time in my life."

It was a coming out, but only in a manner of speaking. Part of the allure was, and remains, the secrecy and the mystery. She was proud of her secret, proud of who she was, but she never talked about it. "I felt like I

had just found a person inside Gerry. I felt like I was the most unique person in the world. I felt it was my secret and nobody knew it but me." At the time she was advertising manager at a weekly newspaper in Bayside. It thrilled her to think that no one suspected she had what amounted to a double life. "I always laughed to myself thinking if anyone should tell my boss that Gerry's a lesbian, she'd say, 'Oh, no, go on. She's the mother of two children.'" When she left work, she would change clothes, "put on a collar and tie and pants" and go out looking "sharp." Elegantly butch.

'Butch' was a category handed to her off-the-rack. It never quite fit. Over the years, she has personalized the uniform, challenged its limitations, and chosen a more comfortable stance. She had a short relationship at the age of eighty-two with a Georgia belle who laughed at her for carrying a pocketbook. "She would say things like 'I do the cooking and the ironing, and my butch will fix the toilet and take out the garbage and do the driving.' The rows we had! I finally said, 'Ellen, this is not going to work. I'm not a butch. You're a femme. I'm a lesbian. I like making love with women. Don't use those terms with me anymore.'" But Gerry does tend to dress in gender. When questioned, she says, "I had skirts. I still have twelve that I'm not throwing away. When I get to be an old lady, I'll put them on. I also have fifteen jackets. One looks more masculine than the next. I don't care."

These days, Gerry spends much of her time alone. It's a little quieter than she would like. The last time she walked into a bar by herself was to meet some friends in celebration of her seventieth birthday. "The whole wall was lined with leather jacketed kids, and I heard somebody say, 'Geez, did you see what just walked in?'" Gerry got off a well-aimed rejoinder, but it stung and it stopped her. "I'd love to go in and sit down and have a martini. Actually, one isn't enough, and two is too much.

Gerry

What a pick-up line: 'Anybody here want half a martini?' But really, the only difference between me now and me thirty years ago is I ain't getting laid. Go find me another ninety-year-old lesbian who wants to go to bed with me! That's my problem now. Even a seventy-year-old. But, then, seventy is my daughter's age, and it would feel a bit incestuous."

Roy and William

William is the epitome of college professor, thick white hair, tweed jacket and tie, but comfortable old sneakers. He is earnest, opinionated, refined, a gentleman of the old school. It is hard to imagine how he must have felt when summoned to the office of the Eighth Avenue postmaster and asked to explain a Swiss magazine that had recently arrived addressed to him. It is a magazine of poems and stories expressing "homosexual love." These are the McCarthy years. It has been judged "obscene." It is illegal. It must not happen again.

If William is earnest, Roy is perhaps a bit irreverent. He matches the formality of William's dress and raises it one with a dash of turtleneck. The sneakers match. When provoked, pleased, or grateful, they write notes—to authors, actors, presidents, friends. They are a pair of gentle men.

William and Roy met in Washington Square Park on a mild December evening in 1949. It is not clear who was sitting, who approached, but they ended up sharing the park bench and the next forty-nine years. Their living arrangements over the years have been somewhat subject to external concerns. They shared an apartment on West 12th Street for thirty-eight years, but when William began teaching at Rutgers, he

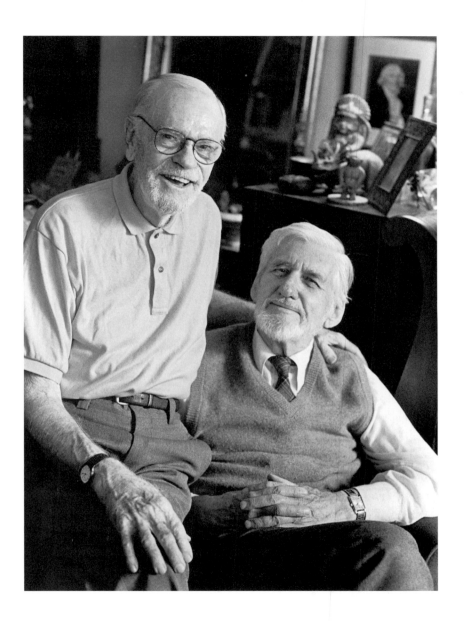

sensed that his status as "unmarried male" made him somewhat suspect in the personnel department. They maintained separate apartments until after his retirement. Last year they both had hernia operations. No more walk-ups. They found an apartment in an elevator building on Christopher Street. As they stand in front of the window, they are holding hands. Roy is making slightly off-color jokes about the pigeons outside, all of whom are apparently heterosexual. He is eighty. William is eighty-two. They are both a little stooped in the shoulder. They lean into each other, and their heads touch, and Roy says to William, "This is it, mate. We will never have to move again."

Their apartment is a little too small for the things they have accumulated in their lives together. They are getting rid of the punch bowl. Every inch of wall space is covered in carefully grouped explorations of favorite motifs. There are lots of snakes. The couch and chairs are overfilled with Roy's needlepoint pillows. He was working on a stunning bust of Nefertiti when I came to make my photographs. And there are books everywhere. They read aloud to each other and always have.

They refer to each other as "mates" and feel deeply deprived and disrespected by a society that forbids them to marry—officially. Unofficially, they have married three times. William says marriage brings with it a "beneficial psychological effect: peace of mind. You're not constantly looking and always frustrated unless you just got out of somebody's bed." Roy says, "I want to be made an honest man after forty-nine years." But beyond peace of mind and the niceties afforded by convention, William has a pension. He was an English professor at Rutgers. Roy has no pension, and the State of New Jersey denies his claim to William's. After forty-nine years of devoted partnership, the injustice of that stings. A young man has recently interviewed them for a magazine article on the issue. Roy says, "I thought the guy wrote a really good article,

nicely written, and I didn't have the reaction William did." William, however, is irate. He claims the piece was filled with "distortions and inaccuracies." "When he first called, he said that the article was to be about two people who had been together for a long time, one of whom gets a pension, and the other of whom doesn't. He wanted to interview both of us. Now, the article comes out, and the headline says something like: 'Former college professor complains about the pension system.' The whole thing was concentrated on me. For many years, Roy very successfully managed a flower shop that was one of the best in New York. He deserved to be noticed." Roy interjects that he even did flowers for the White House, and William continues: "I know the reason that I became the chief focus of his article was that it sells more magazines. It's more sensational to have a college professor be an openly gay person with a lover for forty-nine years. And that infuriated me because I felt I had been deceived. The emphasis was on money and not love."

The ways in which Roy and William's relationship so obviously mirrors a "normal" or "ideal" heterosexual marriage, and the fact that these two so articulately and passionately make a case for the illogic, if not immorality, of forbidding them to participate in that institution, has made them desirable on talk shows and interviews. They have been on television fourteen times. They have been written about and speak frequently to young audiences. They are presentable, even perhaps conservative, men who actively espouse and aspire to a genteel style. Though William refers to himself as a "moral revolutionary," called to live outside of socially normed behaviors, it is a relative term. He uses it to segue into his rage at the clergy. "Here's a whole population of people suffering, and many of them disintegrating, because of the strain, and what are the ministers and the priests and the rabbis doing? They are sending us to the Holy Book for the answers, and of course the answers aren't there.

We're misled. I think we are perfectly normal, and the churches should not only be accepting us, they should be encouraging us to marry. It's destructive. I do not think we need to be fixed. I do not think God makes mistakes."

Roy has a story about "fixes." His sister, Dorothy, having seen him holding hands with his first love in a movie theater, took him to see "a German doctor from Hitler's horror who had just arrived in Huntington." This doctor was supposed to "fix" him with weekly injections in his "but-tock" (strongly inflected second syllable to make a joke out of what might be considered inappropriate language in mixed company). The treatment was expensive, and it "hurt like the devil." "And," Roy adds, "the only thing it was doing was making me hornier and increasing the desire to see more of my friend." He stopped the treatments, feeling "sort of used," but he never felt that there might really be something wrong with him, something for which he should perhaps be ashamed. He is proud to have elicited nothing but charm and delight from his flower shop customers. He is proud to have been on a first-name basis with Mary Rockefeller, with whom he volunteered in the flower program at Memorial Hospital. He was the only man in a group of women volunteers. He says they called him their "thorn among the roses," and when they asked him, "Are you married, Roy?" he told them, "'No, I'm not. I'm a homosexual.' And they all, most of them, couldn't have been nicer. I told them about my mate. The whole thing is so different from when I was growing up."

Roy and William take citizenship very seriously. Roy not only volunteered for years in the Memorial Hospital flower program but also for the Association for the Blind, and William for the Village Visiting Neighbors. They have both been dedicated members and volunteers for SAGE since the early years. They are often invited to speak to young audiences

about their lives and their values. When asked what has kept them together, Roy answers, "We have a lot of patience with each other. And understanding. We have different interests sometimes. William loves to listen to Mayor Koch in the mornings, and I go into the bedroom and shut the door because I think he is one of the rudest people on the radio. And then I have idiosyncrasies that are not what he likes. William is a very spiritual person. I am an agnostic. I just don't feel that anyone knows what's up there, what's down there, where the hell we came from. We have interesting discussions about that. You just have to have patience." And advice? "When we talk to kids we tell them that we enjoy being together. We love to read aloud to each other. We like the theater. We love the opera. We love the ballet. We love to travel. We tell them we hope that they can find a mate, as William and I have done. And be monogamous. And if not, if you do something on the side, for God's sake, use a condom!"

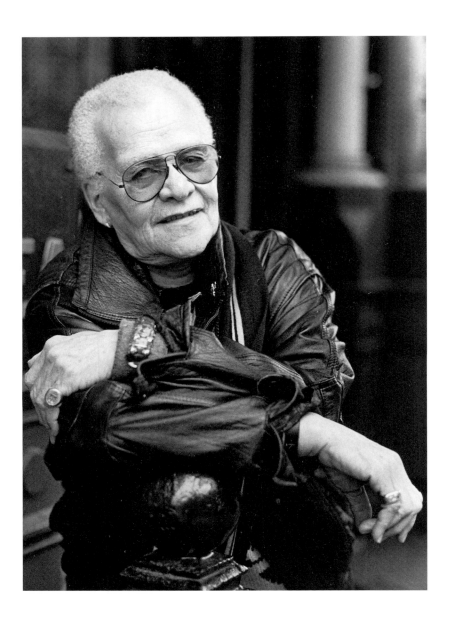

Stormé

There are many conflicting versions of what happened that night at the Stonewall Inn, but more than a few remember that the first rebellious punch was thrown by a woman dressed in men's clothes, a woman who was trying to stop a cop from roughing up a young queen. Alison was sprawled in the street, and the cop barked, "Move it, faggot!" when Stormé tried to intervene. Then he blindsided her, caught her in the eye with his fist. Stormé spun around and hit him back. "There was no fight," she says dismissively. "I only hit him once. I guess I knocked him out. It was nothing."

But it was, in fact, a defining moment in history. The rousted patrons, the crowd that quickly gathered outside the bar on Christopher Street, and, finally, a community decided that they had had enough of business-as-usual harassment from the police. That night they fought back, and in so doing altered the political and social landscape of the city, and perhaps of the country, forever.

At the time, though, nobody understood the significance of that punch. Stormé went home to see to her eye and then rounded up a lawyer and some cash and returned to the scene of the confrontation.

"If anybody needed help, they'd know that they could find me some-where." That's Stormé's way. She takes care of her own.

The woman who decked the policeman that night was forty-nine years old. She was a karate expert, practiced tai chi, and "bench-pressed about 190." She was also quite accustomed to being mistaken for a man. As "The Lady of the Jewel Box," Stormé had raised gender deception to an art form. When the Jewel Box Review came to town, the staging was dazzling, the lyrics witty, and the choreography brilliant. They played the Apollo twice a year, and the other great old clubs in the country: the Howard in Washington, the Regal in Baltimore, the Tivoli in Chicago. The rest of the time they were on the road—exotic, transgressional musi-cal theater, challenging the narrow prohibitions of the McCarthy years. A precursor of La Cage aux Folles, the cast was twenty-five fabulous queens in sequins and feathers, high headdresses, high heels, high camp entertainment. And then there was Stormé, crooning wonderful old jazz vocals into the microphone from the darkened stage, a drop-dead gor-geous young man in a perfectly tailored tuxedo, with sultry eyes, a sen-suous mouth, and the vulnerable defiance of the young James Dean.

Stormé's once-black hair is now snow white, still cropped short. She sits comfortably in the lobby of the Chelsea Hotel, where she has kept an apartment for the last seventeen years, elbows on spread knees, hands hanging down, big hands with big rings. The masculine affect is perhaps a bit rougher now, camouflage pants with a heavy ring of keys, leather jacket, heavy boots. But she still moves with the same catlike grace, the same entertainer's entitlement. Her voice is deep, precise, a lit-tle gruff; her affect, suave and urbane.

Stormé was born in New Orleans on Christmas Eve, 1920, to a white father and a black mother. Her father was a wealthy businessman who could afford to have her tutored at home, but her white face and her fa-

ther's class privilege couldn't protect her from a deep southern caste system left over from earlier times. By the age of fifteen, she had raised too many hackles in a society whose genteel manners masked a vigilante heart. The family "had to get me out of New Orleans or I would have been killed." That is all she will say about them, or why she left. She doesn't talk about family or friends. A pall of mystery and romance hangs over her story, like the Spanish moss and legendary ghosts of New Orleans. But in the meantime, she had learned to fight.

She ended up "in Nebraska, of all places," singing with a jazz band in an amateur contest. A two-week engagement began a career that lasted sixty years. She sang with big bands in the early days and still carries a picture in her wallet of a young bubble-haired beauty in an off-shoulder gown, the epitome of 1950s glamour. When she started the Jewel Box in 1954, she changed clothes. She was thirty-four years old. "They told me I couldn't do it, that I would have a stigma on me. And that I couldn't be the same person. That's ridiculous! Nothing changed. I just was who I was. People used to ask me if I preferred being called he or she. I said, 'Whatever makes you comfortable.'" She insists that nobody treated her differently as a man or as a woman—except perhaps the queens "who chased her all over town 'till they figured it out." Gender categories are just irrelevant to her. "When people make a mistake, and they do every now and again, I say, 'that's justifiable. Don't worry about it.'" And she laughs, remembering how she had to coach the young Jewel Box queens who were trying to walk in heels for the first time. She had done it for years. "I'd say, 'No! No! You can't walk down the stairs like that. You'll kill yourself. Get me a pair of shoes! Let me show you how to do this.'"

Stormé could get a tuxedo tailored to fit more easily than a label. She never called herself a lesbian, even after twenty-six years with the woman she loved. "She was my life. She was a dancer and an aerialist. She

was a beauty, like Lana Turner. I was on the road. I traveled all the time. I had businesses, and she ran them while I was away. She didn't care what I did as long as I was happy. I had a good time being alive." Stormé pauses to make an important correction. "We had a good time being alive."

But her lover died a few months after Stonewall. Stormé closed the Jewel Box and transformed herself once again. Now she would be the "mama bear, taking care of her cubs," full-time. She became a body-guard, for private clients and for lesbian bars. She thinks of it as baby-sitting. At seventy-eight, she sits on a barstool at Henrietta Hudson's, watching her charges talk and play. "I have them all ages," she says. "They're sweethearts. Very respectful. Every now and then I get some that aren't. Then they have to be told."

Stormé has spent most of her life in the spotlight, fifteen years with big bands, another fifteen as the Lady of the Jewel Box, and she is forever part of the history of the Stonewall uprising. But she is a black woman with a white face who dresses like a man and loves women, and she lives to take care of her own. "I used to say, 'Don't let the clothes fool you. Under the clothes, it's the female side of me that's a holy terror. Under here is a stone cold woman who's been fighting her way through half the universe since the day she was born.'"

Hal and John

Hal entered Catholic seminary after high school. He was seventeen, and he was looking for love, looking for God. "That's why you go to seminary—to be near your lover, really, your companion."

Hal has a soft, sweet face. He is not well. His heart is fragile and he moves slowly, carries himself with a careful grace. He has a tendency, when talking about things sacred, to raise his chin, close his eyes, purse his lips, and make his pale skin appear to glow from within. He'd make a lovely saint.

Anyway, he got to the seminary and discovered, much to his surprise and chagrin, that he was spending far more time thinking about Tom than he was about God. Rather than punishment for transgression, though, what Hal got was a confessor, a young priest who Hal is convinced was sent by the Holy Spirit. "He said to me one day, because it was getting very difficult for me, I was very distracted and my studies, well, I couldn't concentrate. He said to me, 'Do you know what's wrong?' And I said, 'No.' And he said, 'Well, you're a homosexual.'

"The minute he told me, it was like a great load off my back. I suddenly knew who I was. 'There's nothing wrong,' he explained, 'except you are only seventeen years old, and you are asking yourself to spend

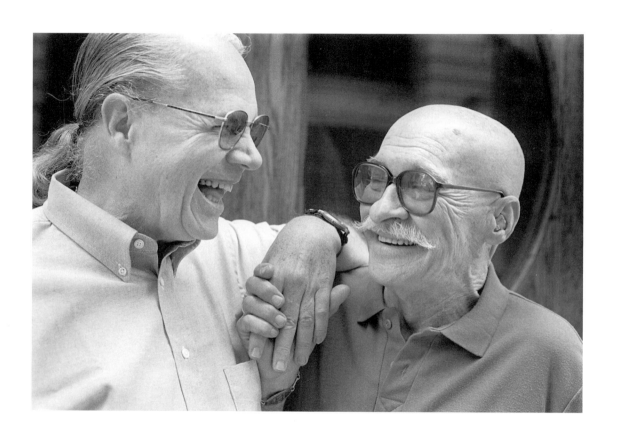

the rest of your life in family with a group of men, and you're attracted to them. That's a very, very hard thing to ask of yourself. You know the rules are that this attraction has got to be subdued. Why don't you give yourself a chance? Go out and decide how things are going. You can always come back.' I immediately went downstairs to the chapel, full of prayer, and I have been ever since because I'm so grateful to the Lord for telling me and making it clear."

The Holy Spirit cannot be counted on, however, to answer every prayer in the most direct way. Reconciling his beliefs and lifestyle with the teachings of the church has been an ongoing personal anguish. He reads carefully, checks citations, finds comfort in radical voices pushing for reform—all searching for proof of Christ's acceptance. Like a good Catholic, he loves the pope and prays for him every day. "He's quite ill. I pray a lot for him. Not that he die, but rather that the Holy Spirit guide him in a way that will make the understanding and the love of Christ more clear."

John snorts impatiently. He cultivates the affect of a Hussar: bald head, long handlebar mustache, steel blue, penetrating eyes, and a military carriage. He is a professional model, a "character type," he says, but the disdain and annoyance he is struggling to control at the moment have nothing to do with acting. Hal reaches gently for his hand before he continues, "They call us intrinsically disordered, but I know that if I keep myself as a loving person, that's all Christ is asking. My gayness is a part of me, a central part. But what we're talking about now is my eternal life. And my eternal life is very important to me." His eyes fill with tears, and he holds John's hand tightly. "I want to make sure that I do the best that I can so that I don't put Christ in the position of having to say, 'No, you have to go to that other place.' I think that would not be so bad for me, but I don't want to do that to Him."

John marshals control while he soothes and waits for Hal to recompose, but he is clearly agitated. When he starts, he only starts calmly: "That's why I have, not a conflict, but a great awareness of Hal being such a good church person and the church being so opposed to his lifestyle. How could you put up with this? How could you go to these people when they keep saying, 'You're terrible! You're evil!' That's a hell of a conflict with me!"

John holds himself as tight as Hal is relaxed. This particular conversation, one I imagine they have had often in their fourteen years together, exaggerates the difference. Catholic dogma makes John furious. He's fabulous when he's furious. "They will accept you, but they won't condone you. And they will only accept you if you are not practicing. I'm seventy-five years old. How sexy can I be? How well can I function with my age and heart medication? I can't function the way that I would like, so the church says they'll forgive me! Hypocrites! I'm suddenly someone else if I'm incapable of performing sexually? I believe I'm still a homosexual because my interests in the present and my carnal desires in the past are and were for members of the same sex, my sex. But older people are where the money is. The gay community is where the money is. The church may hate what I am, what I do, but they say they will forgive me, they say I am not guilty if I'm not practicing. They're only willing to make that exception because they want my money!"

Hal ignores what John has said about the church. He is thrilled to have a ready example of what John means by "interests in the present." He wants very much to tell me that the new (now ex-) executive director of SAGE is "a very physically attractive fellow." Not only physically attractive but, "He's got a spirit, a male spirit, that is warm and giving. I went in to his office last night and gave him a hug and a kiss, and he said, 'Oh, Hal, this is so nice. John just dropped in. Now I've talked to both of you.' Now that, I think, is beautiful. I don't think we're flirting,

it's just that we really like this guy." John says, "It's a homosexual thing, you know? I mean, if he made me an offer or came on to me, I'd say, 'Oh, my God, what do I do now?' I'd panic!" Hal shivers and grimaces— such a thought!

John is proud to be in such exemplary physical condition. He knows he's "still hanging in pretty good for his age." He swims regularly and walks a lot because he believes that "to be attractive and interesting, you must be physically, aesthetically pleasing." He is candid about using his physical attributes to balance insecurities: he wishes he had had more education, had done more exotic things, made and saved more money. But it certainly helps to know that he can "look better than most seventy-five-year-olds, with or without clothes on." He bristles, quite magnificently, when asked if his attempts to be buff and youthful in appearance are grounded in a cult of youth that is peculiar to the gay community. "No! It's in society in general. If you're not young and pretty, you're a has-been. And it applies equally in the straight and gay communities. We are part of society. We read the same magazines, see the same television commercials. Gay men value youthful appearance, just like all men." Nonetheless, John is reevaluating his standards of beauty in what he calls his "declining years." He has recently developed an appreciation for men with "gray hair that really looks gorgeous. And I'm not jealous, but I'm very aware of it."

Years ago, Hal celebrated his "coming out" by taking his mother and his lover to the Blue Parrot Bar. He remembers his mother saying "I don't think I have ever been in a room with so many good-looking men in my life! Oh, no wonder you're so happy!" Beautiful men still make him happy. John, too. But Hal still struggles to find validation in Scripture for the love that he knows is good. His reading has convinced him that between Christ and St. John there was an unmistakable attraction. "It was a tender thing. And Christ didn't put him aside."

Ernece and Caroline

Ernece is sixty. She looks forty, knows it, likes it. She has grace, elegance, and a smile that is a gift and a seduction. And she knows it, likes it. For most of her life, Ernece kept two irons in the fire, so to speak. She enjoyed sex, both gay and heterosexual, and she liked to maintain parallel relationships, one with a woman and one with a man. "It was a way of not committing. It was a way of keeping myself active in ways that I enjoyed without having to say, 'OK, it's you and you alone.' I didn't want to have to say that because I was afraid they might leave me or I would get bored."

Then, in her late thirties, she decided a change was in order. "The principle reason I changed this pattern was out of fear. My friends were coupling off. And I remember hearing this song by the Eagles called 'Desperado.' 'You better come to your senses. . . . ' I listened to that song and it struck fear into my heart. And I thought, 'Oh, boy, you're going to wake up, and you're going to be alone, and everybody else is going to have somebody. You better settle down.'

"So it was out of fear that I made a choice. And my choice was not to seriously date guys any more, but to settle in with women. I don't really consider myself bisexual because my emotional and psychological pay-

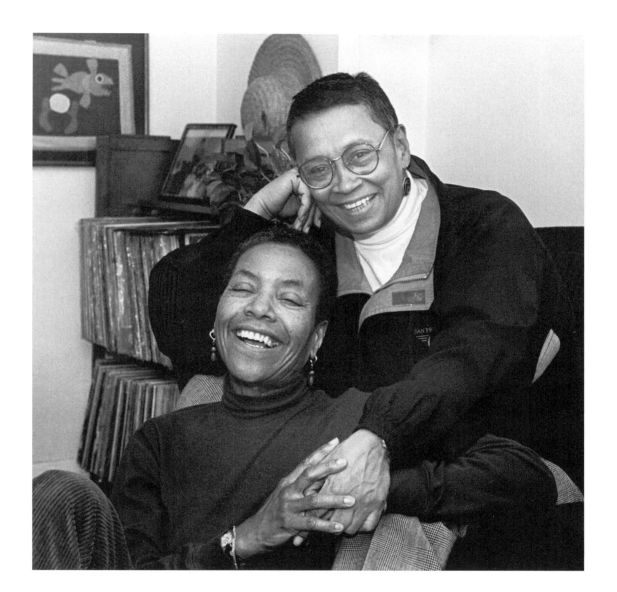

offs are with women. So I found someone, or someone found me. I was in a relationship for ten years. It was a very good relationship, but it was with a white woman, and that became problematic for me. It was difficult even though she was probably one of the most enlightened white women—politically active, politically challenging, the kind of person that just wouldn't let shit go by. There would be situations where I would want to say something, but wouldn't. She'd step right out there and say, 'What you're doing is wrong,' or 'What you're saying is wrong,' or 'What you're planning is wrong.' A woman who could really walk that walk. I had a lot of admiration for her, and still do. But it became hard for me. I really missed . . . I don't know how to put this . . . I missed the Blackness. I felt like I was betraying, quote, 'my people.' I'm not proud of that because I think any feelings that I had like that weren't my own. I think they were borrowed. I mean, it was in the air. I allowed it to influence my own life. But I was missing a lot of the kind of day-to-day stuff I can have with Caroline. I can just talk about music and I can make some reference to the fifties and what was happening and she immediately understands, and lived it."

Caroline echoes that thought. "There's so much! We finish each other's sentences and we did this from the beginning. It's just so wonderful. We'll hear some trite phrase and break into the same song. You'd think we grew up side by side, instead of she in Chicago and I in New York."

Caroline's moment of choice followed a marriage, three children, and a live-in affair. She had grown up in Harlem in a warm family. "My father had a master's degree from Leyden University in Holland. He spoke, read, and wrote seven languages, but, still, the only job available to him was janitor in the building where we lived. The up side of this was that we grew up with both parents at home. Mami was soft hands and loving smiles. Dad was laughter and music." She found his qualities

in two men later in her life, but she outgrew them both. She knew she wanted more, and she didn't know what that might be. The man she lived with after her marriage broke up told her she was a lesbian. She thought it was funny at the time, but there had been a moment, while she was still married: "A woman from the neighborhood came by when I was alone. And she danced for me! She was so beautiful—so very sensuous. Well, I don't move quickly. So I mulled it over for a week. And when I finally said, 'Why not?' she had married and gone to St. Croix. I mulled. She moved."

After she left her second relationship, Caroline knew she wanted to explore. "I knew that I could function in the straight world, but it was too limiting. I needed to live my life in a more real and natural way. It wasn't just the physical or the sexual. It was a psychic normalcy. In a real sense, the role of the straight woman is so narrowly defined it's enervating trying to live there. Lesbians live more natural lives. When Ernece walked into that SAGE meeting, the sexual and physical fell into place as well. I was ready."

And determined. Caroline is nothing if not a quick take. She has been a systems designer and programmer for twenty years and a winner on both *Dream House,* a sixties quiz show, and *Jeopardy.* But she hadn't spent much time with lesbians, and wasn't sure if there were exclusive definitions or qualifying criteria. She designed. "I was afraid Ernece might suspect that I was only looking for kicks in the lesbian world, so I didn't tell her she was my first until much later in our relationship."

Neither of them, I suspect, particularly care how others would define them. Their experiences have bred in them a healthy distrust of dominant social institutions and values. They both grew up in big cities in warm, committed, working-class families. Ernece's father was also college-educated and, as a lifetime employee of the post office, is just one

more example of "an old story, a Black man not being able to get a job commensurate with his education." Ernece calls her family "race people," a term from the twenties used to describe "Black people who have a grounded and thoroughgoing consciousness of racism and being active around it." Her mother walked picket lines with her as far back as she can remember. Ernece walked away from a college teaching job (she has a Ph.D. in English and urban education) to work full-time with Dr. King in the freedom movement. Her activism is largely race-directed and has spilled over to the work that she now does for pay, "because working in diversity as a consultant is also trying to address issues of racism." She says she feels "the pain and the restrictions of racism much more than I feel any pain of homophobia. Which is not to say that I don't feel that, but it has not been the kind of lifelong experience that my contact with racism has been."

These two women wear their life choices proudly and publicly. Caroline says, "When we're out together, we walk along the street holding hands or arms linked. I've never gotten negative reactions." They are both "out" in every part of their lives, but Caroline chooses not to wear a ring. Ernece does. For three reasons. "I don't want to be in a gay situation and if anyone is attracted to me I don't want them to think 'Oh, she's available.' And I wear a ring because I want to look married. I like being married and I want people on the subway to see my ring. She's attached. Desirable. Yes. Desirable and taken. So those are two messages I want to send. The other reason I wear a ring is because my color is such that gold looks really nice on my skin. It's just vanity. I like the way it looks. But I guess as important a reason as the public ones is that I like the idea of being in a relationship that I intend to be in for the rest of my sane life. I like having a symbol of that."

Ernece and Caroline

"For the rest of my sane life." Both Ernece and Caroline have walked away from comfortable but unfulfilling circumstances more than once, shedding outgrown lives. They've insisted on choosing, actively designing, and creating their own lives. Things don't seem to happen to them as much as they make things happen. What I love most about being with these two is that the language they use to describe what they have found in each other is one of desire, not one of compensation. As Caroline says, "Ernece is my all. She comes with the requisite laughter and music, plus an intimacy I have never known before. I cannot see living without her. It frightens me that for the first time in my life I'm with someone about whom I cannot say, 'If need be, I can walk away.' This I cannot say. This I could not do."

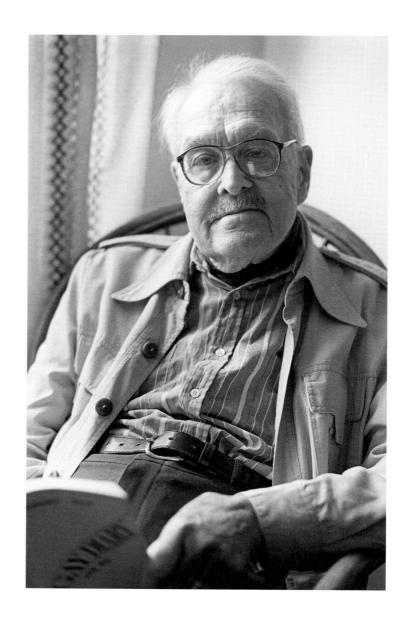

Donald

Donald is a writer—a prolific one. He has published innumerable articles, several books, and six volumes of *Gay Diaries* from the journals he kept throughout his life. He has thought about most everything and has opinions about most everything, very clear opinions, and he doesn't keep his opinions to himself. Never has. He punctuates conversations with some version of "I wrote an article about that for *The Advocate*." And he's been doing it for a long time. He made his first writing money in 1926 at the age of eleven with a winning essay for the New Jersey chapter of the Women's Christian Temperance Union. His essay described how Alexander the Great killed his "friend" in a fit of drunken rage. Alexander was an important role model for a boy who had just been seduced by both the landlady's daughter and the minister's son and had enjoyed the minister's son a good deal more.

Donald is now eighty. He hates that in himself as much as he hates it in other people, but it won't go away. He has to do his own dialysis at home three times a day to augment regular clinic sessions. Sometimes he has to rest twenty times between the bus and his building, but Donald fiercely refuses to acknowledge that the rules that apply to other people apply equally to him. That bit of hubris may very well be what

keeps him alive. Who says an eighty-year-old diabetic can't hire pairs of hustlers out of HX and crow about it afterwards?

Donald's childhood was richly chaotic. His mother was a lesbian. "She dressed in knickers and pants up until the time women generally came to wear them. And then she gave them up. And the same with the pipe." She was inconveniently attracted to married women and prone to histrionic and flamboyant behavior when her relationships fell apart. Her financial behavior was "deplorable." She forged and kited checks. "Whenever she couldn't pay the rent, she decided to buy the place. My father would be sent for, and then we'd have the hysterical blindness, the running away from home, and all that stuff." She dragged Donald around the country in pursuit of her latest object of passion, until her possessiveness drove them off or a man reentered the picture. She was manipulative, passionate, unstable, colorful, witty, and gloriously trans-gressive—not your typical list of maternal attributes.

Donald learned early on that his best defense was to give at least as good as he got. They dug for each other's vulnerabilities and pressed an advantage mercilessly. He laces stories with deadpan observations like "She wanted me to move back in with her. She wanted to get me away from Rich. She thought he was getting his claws in. She didn't want to share me. I was never flattered that she was fond of me, because I was a man, and I didn't believe that even a son could overcome her hostility to men. But I knew what she wanted. She knew that if we lived together the rent would be paid and the house would be cleaned, two things she didn't like to do. She brought me up to be her housekeeper. She hated to lose me."

It's tempting to make this piece about his mother. I expect that is something Donald might recognize. But what it seems to have done is encourage him to be obsessively orderly, formal even, in the way he

presents himself. One is not inclined to kid around much with Donald. One might be witty, but not silly. Certainly not vulgar. One is not inclined to call him Don. Richmond never did. Donald was twenty-nine when he met Richmond, whom at forty he considered an old man, "And I was death on older people." They both resisted a committed relationship for a short time, but they simply had too much to share, too much in common. For the next forty-three years they were partners. Richmond died seven years ago. Donald is not a conventionally religious man, but he prays every day. "The prayers have always started with 'Thanks for Rich.' And they still do. Because I figure it was a sign of God's love. I never would have found him. He was the aggressor, claiming to admire my tan when I came into the steam room. It was not my tan he was admiring!"

The story of their courtship is delivered with a flat affect, but Donald's timing is that of a seasoned storyteller. He works the details:

> First thing I know, he wants me to save a place on the roof. I went to the sunroof with him regularly. And then we have to discuss religion. And I thought, "God, he'll be taking me home to mother next. Why do we have to discuss religion?" Because I didn't care what he was. I might have if he'd been a Catholic. At that time I probably would have. He had little spells when he decided to go to church and I wouldn't go with him. I used to sit outside—this didn't last very long—but I used to sit outside. He had become an Episcopalian as an adult because he liked the dresses that the priests wore. And all that high stuff that I hate. He had an audience with the pope and he kissed the ring. I said, "You kissed that filthy ring?"

Their relationship was not monogamous. "Monogamy has nothing to do with us. I wrote an article about that, too. 'Gays and Monogamy.' Because we can't be married, and monogamy has to do with how many

people you're married to at the same time. But it has come to mean, to a lot of people, to most people, fidelity. It has nothing to do with fidelity. Monogamous people are as unfaithful as anybody else." And he quotes a study that suggests that two years into a relationship an astronomically high percentage of gay men have had an outside sexual encounter. Conclusion: "Gay males do not break up [over issues of infidelity]. They know how to accommodate the lust of their partner. Probably because they are male."

But for all the precision, the clarity, the certainty, Donald does not talk about sex in an orderly fashion. He tells stories of break-ups, despair, leaving the gay world forever—not exactly accompanied by a back of the hand to forehead gesture and a threat to jump, but one recrimination did include a threat to join the bricklayers' union, to work with his hands and get a few calluses. He made scenes because he was jealous, but he knew "even when I was most in love, in the very beginning, I couldn't pass up a good-looking man." Rich regularly had dinner ready for him when he came home from the baths, but Rich gets labeled "a liar" because he tried to camouflage some of *his* liaisons. He wouldn't live with Donald for ten years for fear of jealous scenes. "And I would have." And he did.

In the end, Rich left an extraordinary memento mori. After he died, Donald found what he calls The List. It includes the name of every man Rich slept with in the course of his life, alphabetized, with locations, and an asterisk by the names of those he slept with more than once. "People I had made scenes about were not on there. I found people I'd never made scenes about and didn't suspect were there. I've tried to deal with that in a story. I've written it and rewritten it and rewritten it, but I never got it right. Last night, I thought maybe I could do it in a poem."

Donald likes to talk about himself. The *Diaries* are about his life and times. They don't pretend to be about community. They're about Donald. ("Well, I wasn't that social an animal.") He puts himself at the center of entertaining, exotic, and provocative stories. They also grew out of his disgust with the available literature of the time, "all about suicide, murder, and drag queens. Never any happy couples. And all around me there were couples that had had long relationships. I knew it was possible. But the public did not know that. And they didn't know about the sheer fun. Don't forget the gay times! Because so many of the people, D'Emilio and Duberman even more, emphasize the bad—the bad experiences with therapy and broken love affairs and so forth. So I said, 'Don't forget that it was sometimes fun.' Probably the most fun was when you found somebody to sleep with who was fun. Good talkers. I always liked the good talkers."

For all of his bluster and opinion, rising above the sardonic and emotionally controlled storyteller is the lover speaking. The story he tells is poignant in its acknowledgment of irreparable loss. Donald the sardonic says, "What attracted me, after I got over the age bit, the hairy chest bit, the hairy shoulders . . . " But he goes on to list the multitude of interests he shared with Richmond, from theater to travel, tennis, politics, needlepoint. And finally, "We both gossiped. Going to bed and putting the lights out wouldn't stop us, and probably putting pillows over our heads wouldn't have stopped us. We just had so much to say to each other."

So they talked and talked, forty-three years of talk, but Donald and Richmond never talked about how they felt about each other. "He came close, he came close . . . ," Donald muses. After Richmond's stroke, when he was confined to a chair and could no longer write for himself, he

asked Donald to fill in a party questionnaire for him. In the blank for "the happiest moment of your life," Richmond asked that he write "Meeting Donald." Donald's eyes fill with tears as he remembers. "I was so aghast my jaw dropped. So I got up and went over to hug him, and he put his arms up. That's as close as we got."

Sandy and Eileen

The curtain rises on the Kernsville conservatory stage and the spotlight is on Sheridan Kern, poised at the piano. The audience is hushed in ardent anticipation. As the maestro begins to play, rapture fills the hall and the women swoon in their seats. "I was a superb musician," Kern remembers. "I was pianist, conductor, composer, and the women just flocked to me. I was like Liszt and his magical ways with the piano, the romantic music. The women would literally swoon."

Or at least so it was in six-year-old Shirley's fantasy. The reality of her life in Brownsville was more mundane. Her father was a Russian immigrant, a peddler who sold oranges out of a baby carriage to avoid the pushcart licensing fees. Her mother was a "findisher (you know, like a plumb-ber). It was her job to clean off all the extra pieces of thread." She had been crippled by meningitis as a child, and it was Shirley's job to meet her mother every day at the bus stop and serve as her support on the way home. "In those days it was a *schande* (Yiddish for 'shame') to be disabled or to use a cane. My mother would fall a lot. People would come over to help and I would be like a wild animal. She was *my* responsibility. I didn't want anybody feeling sorry for my mother or me."

Sheridan Kern had no need to resort to such common displays.

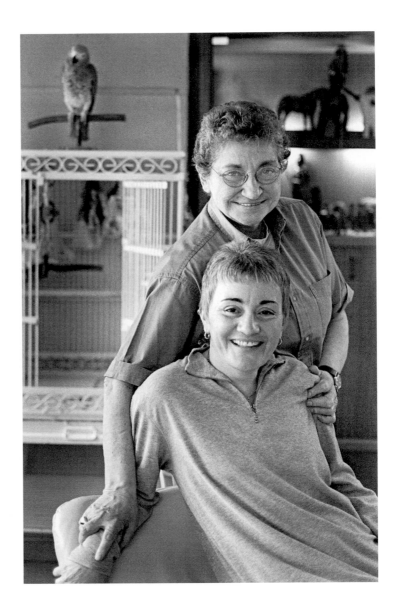

Kern's solution was masterful, elegant: the invention of a motorized wheelchair that was, in fact, Kernsville's reason for being. "All the people there worked in the wheelchair factory. It was because of me that they had their homes, their jobs, their families, everything. I was like God. That was my fantasy."

"As long as I was fantasizing, why didn't I fantasize that my mother was well? Well, I didn't. What do you make of that?"

One night during the war years, when the lights went out for an air raid drill, Shirley found herself sitting on a stoop with her friend Nikki. "Nikki had long hair and I put my face in her hair, smelling her and holding her very tight, and she let me. And then the lights went back on. There was a neighbor there, and she looked at us and said, 'Are you lesbians?' I ran to the library to look up the word, and it described me to a T. That's when I really started seeing myself in the spotlight. I felt so special, so extraordinary. I felt so good about myself."

So Shirley added sex to Sheridan Kern's repertoire. With her arms around her mother's ironing board or dressed in her father's clothes, she was Sheridan the Lover, Sheridan the Star, Sheridan the Fearless, Sheridan the Highwayman. Just the image in the mirror, with socks stuffed in the pockets, was enough to bring her to orgasm. "I never touched; maybe just a little rubbing. My imagination was so strong, and my desire to be a man was so strong that I actually felt that I had a penis. I always came very fast because I thought I was a boy."

Sheridan was Shirley's secret, shared with no one. She went to her high school prom "in a gown with a guy. I felt freaky, but I went anyway." When her mother said, "So Shirley, when are you going to get married?" she took a chance. "'Mom, I'm never going to get married. I like girls.' I didn't think she would know the word 'lesbian.' And in all

her naiveté and good-heartedness she said to me, 'All right. My wish is that you should meet a nice girl who will take good care of you.'"

Shirley took her mother's advice and her blessing and, after high school, left Borough Park for Manhattan and Minta, who, at least for a while, did take care of her. "Minta let me be her butch. She let me be who I was." More precisely, Minta let her be "stone butch"—the sexually active lover of a sexually receptive partner, touching and loving women, but never allowing herself to be touched. One of their first stops together was the Army Navy Store on Christopher Street. "I got rid of all my girl clothes, and that's when I legally changed my name to Sandy."

She got a job as an elevator operator at a Fifth Avenue hotel. "I loved it because I had that beautiful uniform." She actually imagined that she was "passing," until the manager pointedly decreed that all women operators had to wear bows in their hair. Sandy couldn't wear a bow. "I lost my job. I'm always cursed with the look of femininity. No matter what, I was unmistakably a boy—I mean a girl."

Sandy worked for NYU as a secretary for forty years. She never tried to "pass" again. "I wore skirts and heels and stockings to work. It made me lonely. I had to live at night." It was as Sheridan that she went to the clubs "with socks in my pants. I'd have several orgasms before I left home, just seeing that nice big lump there, and more when I was dancing with the girls." She actually considered surgery in the early sixties. Conversations with others who had gone through it convinced her that the technology was still too primitive, but she wanted to, "That and my nose. I wanted to do my nose, too. You know, I had to fight more because I was Jewish than for being a lesbian." It seemed that only with Sheridan's magic could she escape both her gender and her ethnicity.

Eileen has sat quietly through Sandy's story, often taking her hand, allowing her neck to be rubbed, never interrupting. Gently stroking Per-

ry, her gray parrot, who is swaddled in a blanket like a child, she is a perfectly serene presence. Perry is anything but. From the safety of her arms, he meows like a cat, moos like a cow, demands to know where Sandy is, and, in general, loudly mispunctuates our conversation with startling high drama and an occasional nip. Eileen indulges the impersonations, if not the nips. She continues to soothe. She is thirty years younger than Sandy; a soft-voiced M.S.W. with a degree from Columbia who works with abused and neglected children. Theirs is a new relationship, but not, for Eileen, a surprising one.

Eileen knew "for sure" she was a lesbian when she was ten, and her first love was an older woman, an art teacher, who initiated her into sex when she was twelve. "I never got over it. It was one of the most wonderful experiences I could have ever had." Two years later, hounded out of Italian Bensonhurst by homophobic classmates, she ran away from home. She was fourteen. A series of older women lovers mentored her and supported her through high school, then college, and finally through graduate school. Last year, she volunteered for SAGE's "friendly visitor" program, "to help older lesbians who are not physically able to get around, who are isolated—because I had felt my own isolation. I felt all these older women gave to me, and I wanted to give something back." There she met Sandy, who had taken a job at SAGE after she left NYU.

Sandy was initially resistant to Eileen's advances. She found Eileen's youthful energy and enthusiasm for new experiences daunting. And she was not prepared for the more fluid sexuality that Eileen took for granted as "just a girl loving another girl." "Why," Sandy wanted to know, "is this little baby dyke interested in me? She isn't my kind of woman. No other woman ever wanted to touch me—it was *natural* the way we came together sexually. Eileen was different. Not in my whole sixty odd years

of love experience have I ever had someone like Eileen. I felt like she was trying to take away my butchness. I was very upset."

Eileen is struggling to understand. "I felt it wasn't right. And then I put it on myself, that I wasn't attractive enough, that I wasn't feminine enough, that I wasn't good enough. I couldn't get those very strict roles of hers." But, she adds, "Sandy makes me feel feelings that I've never felt before. I see her as a provider, like a man. I don't want her to be a man, but, oh, I would love for her to be able to impregnate me. She would be that perfect father. She would be good and she would love that child to death. That's *my* fantasy."

Between them, this fantasy is a powerful one. A month or so back, Sandy admits, they played it out, and Eileen actually missed her period. But she also admits to being in "some kind of transition" that may be as much a function of age as it is of Eileen's influence. "I don't feel very masculine or feminine anymore. I let Eileen touch me where no woman has ever touched me before. I can't even touch myself. I have a brick wall there. In my mind I don't even have an opening. That's how it is." Or, rather, that is how it has been. The romantic maestro, at the age of seventy, is still learning new magic, making new music, and making the women swoon.

Blackie

When Blackie decided to settle down with Helen it was 1955. They were in love. They wanted the same things. "See, I wanted a wife that stays home, that cooks, irons my clothes. It's very hard to find someone like that, you know. I didn't want her to work if I had a good job." Helen was perfect. They moved in together. Blackie stopped drinking. They got a puppy and waited a year to be sure. Then they planned a wedding.

Blackie's uncle was gay. He had always promised, "If you find a woman that you love, I'll make you a real wedding." Helen bought a white dress and high-heeled shoes. She towered over Blackie, who was, she says, five feet tall before she shrank. Blackie was so nervous that she chewed gum all through the ceremony, but it was a spectacular event. There were six bridesmaids, gay male friends in pink taffeta. The butches wore tuxedos. When Helen died in 1987, after thirty-two years, Blackie buried her with their wedding pictures on her chest. Among her sadnesses she lists Helen's final refusal to let Blackie call a priest when she was dying. Helen was a devout Catholic, but, "She thought she's a sinner because of what she was. I wanted to go to hell with her!"

She still wears the chunky gold band set with diamonds that was her wedding ring. It is one of many, twenty-one to be precise, twenty on her hands and one on a chain around her neck. The one around her neck is a woman's ring. "I just wear it. I don't know who to give it to yet." The rest are men's rings: one belonged to an ex-lover's father, another to a nephew who was killed in Vietnam. Each comes with a story, what is left of relations and relationships. Her hands have been worked hard, and one finger is missing the last joint. That's a good story, too. She was drilling a fuel pump with some guys where she worked, and here comes "the new chick that works down in the office." Blackie looks up and whistles and "Pow, I get the top part of this off. And I says, 'Oh, shit, Herbert, my finger's cut off.' He don't believe it. And the women are screaming. And I'm walking by showing my finger." She says, "Cool, baby!"

Blackie plants herself in front of me with a swagger because she's going to tell me an even better story and she knows it. "You see, I was born a twin. My brother and my mother died in childbirth. And I was born with both. There's a word for it, but I can't remember." Hermaphrodite? "Yeah, that's it."

When she was seven a doctor put her in front of a fluoroscope and knocked her godmother out cold with the information that Blackie had a penis and two testicles as well as the vagina that had earned her the designation 'Female' on her birth certificate. She was less surprised by the information. She had always known she was different. Blackie says she looks like a female on the outside, but never felt like one. She always refused to dress like one, and earned herself the nickname Butch when she was little because she was tough and scrappy and liked to send her dolls careening down the hill in their carriages with their hair aflame.

"When I was sixteen, my uncle says to me, 'You want your sex changed?' I say, 'Yeah, I wouldn't mind. That would be great.' He took

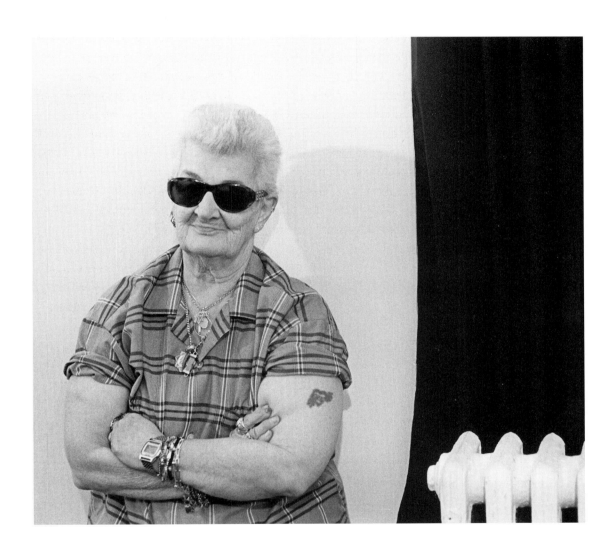

me to a Park Avenue doctor who says they'll have to send me to Europe. I never got it. But if I was twenty today I would do it. If I had the same feeling like I have now, I'd be a man. I'd be a merchant seaman. I like to travel. I like to move around. I'd be overseas banging all those broads."

Her life would have been hard anyway, even if her father hadn't blamed her for his wife's death. But he simply walked out when she was born, leaving her eight siblings in foster care and Blackie in the care of her godmother. She was a sickly kid, in and out of the hospital, and when, at nine, her health problems got overwhelmingly expensive, her godmother sent her back to New York. She never saw her again. "I lost all my love when I was taken away from my godmother. She couldn't take me back on account of my health. So my father put me in a home."

And then another. And then another. She was different. She was almost completely uneducated, and she was completely alone. It made her tough. "I'm not kidding," she says, "I was really tough." The first time she was with a girl she took her up on the roof. "We started talking, and I said, 'Let me see your tits, or I'm going to beat the shit out of you.' That's when I got tough. When I was scared. And I got up and I bagged her. Wow! What a feeling that was."

Six foster homes later, she ran away. She stole $20 and got on a bus that happened to be going to Providence, Rhode Island. A social worker found her on the street, hungry, dirty, and exhausted. She took her home, fed her, bathed her, discovered she was a girl and decided to keep her. Blackie stayed for a while, but she was afraid the woman would turn her in if she misbehaved. Besides, "I do it the other way, but she wanted me to be a lesbian. I like it my way. You know, I like to get on top. See, I tell all my women, 'Don't touch me. I'll touch you.' I'm old-fashioned. I'm the butch. You're the femme. I love women. Not the lesbian way. The man's way."

The year she spent on the medical ward at Bellevue provided the most consistent schooling she ever got. Combined with her gender issues, her lack of education made it hard to find good jobs. She looked like a man, felt like a man, so she tried using a man's name, even learned to pee standing up when there was only one bathroom, but people kept finding out and firing her. The guys at the union were kinder than most. They sent her out on interviews as a box girl. She took to presenting herself with "Ma'am, I'm a female. I'm from Local 119. I'm a boxer. Am I hired or am I fired?"

And she kept landing in jail. Sometimes for dressing like a man. Sometimes for fighting. So often, she says, that the cops from the 47th precinct would greet her by name. She learned to wear female socks to circumvent the letter of the dress codes, but her temper was a problem. She drank too much, and she liked straight women. It was a dangerous mix. When people pissed her off, she often hit first. She "messed some of them up pretty bad" before she met Helen.

Blackie calls it "comical" that when she was a teenager in the 1940s, she didn't know what she was. "I used to go to Harlem, and they called me bulldagger, dyke, stud. I go down to the Village. They called me a lesbian. And I said, 'What the hell am I? A dog, or . . . I didn't know what the hell I was!" She never had a period. She shaves her mustache on occasion. You can still hurt her by calling her a woman. "Don't call me a woman, not when I got man's clothes on. Wouldn't that be stupid? On my birth certificate I'm a female. That's the law. But I never looked like a woman. And I don't feel like a woman. Never did."

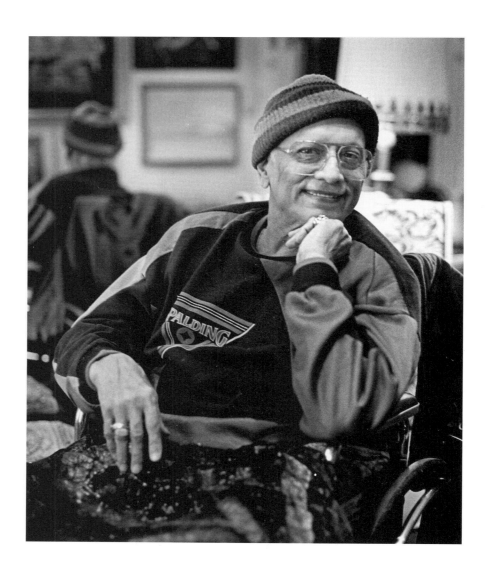

Bhaskar

When Bhaskar danced the Cobra Dance, it seemed as if the cobra spirit had invaded his body. His torso writhed, his stomach pitched and rolled as his body drew on and transformed the ancient forms and disciplines. On stage, he could be both Siva and Parvati, the male and female principles. He could be Krishna, king of the Dark Chamber, or the Setting Sun. In India, he outraged the purists with the sexuality of his performance. In Vegas, he painted the bodies of his dancers and sent them naked onto the stage. He danced for Nehru, and Queen Elizabeth II, and he played Carnegie Hall with Josephine Baker. He danced to entertain, to give shape to old stories and universal truths—and to delight an audience.

It has been twenty-seven years since Bhaskar danced the Cobra Dance, or any other. Twenty-seven years ago he fell from a darkened stage while setting the lights for his next performance. The multiple fractures in his hands and his legs might have healed, but his spine was broken in four places. He was paralyzed from the waist down. This man, whose life had been defined by his ability to move with stunning agility, has been confined to a wheelchair since he was forty-seven years old.

Bhaskar was born Bhaskar Roy Chowdhury in Madras in 1930. His fa-

ther was a famous artist and a very wealthy man. As a child, he was sur-rounded with luxury, opportunity, and entitlement. He was also gifted with an exquisitely beautiful face and the prized light skin of India's an-cient Aryan invaders. "If you are born with very fair skin, then you are Maharani and Maharaja." He went to the best European schools, and "got a taste of what the Western world would be like." The British, he decided, "are individually nice people, but as colonialists, they have no couth."

What they did have was a tradition of turning a blind eye to sexual experimentation among schoolboys. Bhaskar was about ten when he un-derstood that some of his inclinations were not sanctioned by society at large, but he also understood that he had protection. "My father was too powerful. The governor was our friend. The viceroy was our friend. There was no way they could do anything to me, whether they liked it or not." By the time Bhaskar was in college, he recalls, "Everybody was in the closet, except me. I never grew up with any kind of hang-ups. If I liked women, I went to bed with women, and if I liked men, I went to bed with men." When he realized that people were highly offended, he shrugged it off as unimportant. His father said, "My son, straddle the fence and enjoy it. I can only sit on one side."

Like many British schoolboys, Bhaskar took up boxing, winning his first fourteen professional fights and perfecting a body worthy of his ex-quisite face. His last fight convinced him he would never be great and would certainly lose his looks trying. It took nothing, after the boxing debacle, to lure him into the movies. He was an overnight success. He played "Varzan," the Indian equivalent of Tarzan, and when he refused to scrape his knuckles swinging through the trees, he was again in-dulged. Only his father was dissatisfied. "What is this? You're not danc-ing. You're not acting. You're like a monkey jumping up and down."

Stung by his father's artistic disdain, he began to take lessons from the great living masters of Kathakali, Bharatantatyam, Kathak, and Manipuri, the oldest traditions in Indian dance. His invitation to New York came in 1955. He thought, "What is the queen city for show business? Conquer N.Y. and you've conquered the world." At twenty-five, already a star, he set out to conquer the Queen. His first agent said Roy Chowdhury sounded like an Indian cowboy. He became simply Bhaskar.

A New Yorker now, Bhaskar's new life was very much in keeping with his history. In 1957 he married Buddy Holly's manager, but maintained an apartment for an aspiring actor who was also an ex-seminarian. Joan and Mark were close friends throughout. Neither, he claims, were "one little bit" jealous of the other. Joan and Bhaskar had an understanding: "I could go to bed with any man, but no women. I never went to bed with another woman" until Joan died in 1963. "I loved her very much. Sexually, we were very compatible. She lived in the Village. Mark lived on the Upper West Side. I fluctuated. I made house calls. I had a toothbrush, shoes and socks and underwear in both places." But his mail always came to the apartment he shared with Mark.

"Mark and I were lovers. We were in love with each other. But the sexual part of it was almost nonexistent. We hugged each other, we cared for each other, we shared everything," including trips to the baths. It must have been unnerving for Mark, a shy man, to arrive at the door with Bhaskar the Great. "I was a name in New York, so going to the bathhouse was a cinch. Before I could say anything they were lining up at the door. Sometimes fights broke out. I'd go for a swim."

Bhaskar has had to reinvent himself since his fall. Now a painter and a writer of children's stories, he has made his fourth-floor walk-up apartment into home, studio, and testament to former incarnations. Friends help him down the long staircases on the rare occasions he ventures out

of doors. It was Mark who stood by throughout Bhaskar's hideous accident and the year of recuperation and therapy. It was Mark who brought him his first canvas and paints and encouraged him to take up his father's art. It was Mark who arranged for his first exhibitions and encouraged his writing. And then Mark became ill. Bhaskar could not get his chair into Mark's room when he was dying, and it almost broke his heart. Mark died in 1990. Bhaskar decided to live.

Ensconced in his sunny apartment, surrounded by vibrant color and lissome images, Bhaskar paints and writes and talks. His conversation is as colorful and high energy as his art. Light glints off mirrored surfaces. There is movement and illusion everywhere. He brings his legs along with such good humor, nestling them gently on flashy pillows and covering them with an embroidered throw, that it is almost too easy to forget the weight of their lifelessness. The phone rings constantly. He has many friends. And though he is quick to offer a viewing of the Cobra Dance on tape, to share a memory of a time past and a dream shattered, it is in the light of the present moment that he chooses to live. He is still the consummate entertainer. He is still the flirt and the naughty boy who can't help flashing bejeweled fingers, framing the face that always got him what he wanted and lacing everything he says with innuendo and erotic fantasy. Above chair level, the walls are rich with the masks and headdresses he wore in performance, with the paintings he has drawn from memory and imagination, and with exotically androgynous photographs of himself. Everything is immaculate, sexually suggestive, visually playful, richly colorful. From chair level down, the corridors are clear.

Adrian

At forty-one, Adrian still felt he had to lie to his mother about why he wasn't coming home and where he was spending the night. His mother was alone with his sister, who was born mildly retarded. Adrian lived at home, taking care. When he spent time with lovers, he made up stories about travel complications and curfews. When his partners grew frustrated by the limitations, they left. "Since I supported my mother and my sister, I could never move. Remember, this was the focus of my life. Today, maybe I would have moved in with my lover. Then, I would see him whenever I could get away from home. But that was not enough for him. He wanted a real relationship. I did, too, but it never occurred to me that I could have that." So his mother never knew. She couldn't have known, or she would never have made those slightly cruel remarks about sissies on the street and the screen.

Yet his parents must have had some idea that something was "amiss." Adrian remembers overhearing a chilling family discussion in which the Boy Scouts was raised as a possible antidote to his propensity to play with girls. He learned to toe the line at great cost, guilty and shamed by his transgressional urges and experimentations, at least until the army showed him how to cross over for good. In the service he

found community. He learned to respect himself and others like him. He embraced identity, learned to call himself gay, not just sergeant. "I can remember this so clearly. The first time we faced being fired at, some of the real macho guys panicked. But this other gay guy who was with me had such a sense of drama. He said, 'My gosh, it's like a De Mille film!' It was like a vision of being Bette Davis on location for a movie." Adrian himself fully expected to panic when he first heard shooting, but he believes that living through "the horror and guilt of homophobic prejudice" had helped him, and other gay men, develop useful coping mechanisms, among them "drama, and a sense of humor."

Adrian lived his life taking care not to be exposed to judgment or censure. He worked in advertising, a world not particularly known for homophobic attitudes, and he developed a large community of friends, but he was always careful about what he said and to whom. As far as his family and his co-workers knew, he spent his Fire Island weekends in the Hamptons. And one of the most traumatic moments in his life was the night he was arrested in a Greenwich Village bar and spent the night in jail. He was frantic about what it would do to his mother if she found out. Adrian doesn't remember the need for secrecy making him angry. Annoyed, perhaps, but "I just accepted that this was the way it was. I went along and played the game." It may be that the game itself held a certain fascination for him. He describes the scene in the bars and the parks and the public areas as "terrifying" and "extremely dangerous," but admits that "there's a lure to something like that, or there always was for me. The search as well as the actual sex was very exciting."

Adrian always was the consummate good citizen. He calls himself "a professional New Yorker," one who resents criticism of his city and believes in doing something about its problems. For thirty years, he volunteered in a children's reading program, but did nothing that might

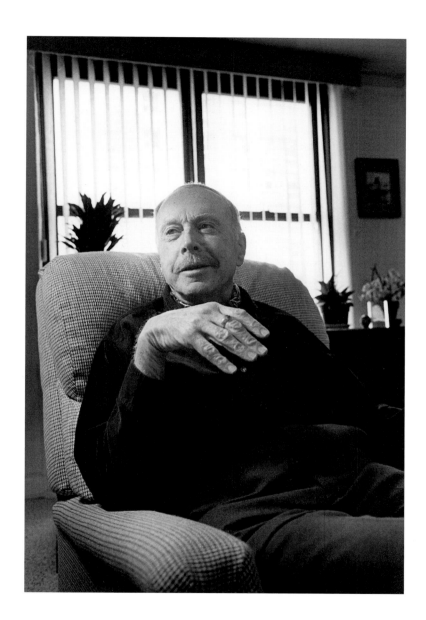

connect him with the gay community. He witnessed the changes that resulted from activism from a safe distance. "In a sense I was very pleased, but I didn't want to be associated with it. I think when you've grown up in an era of suppression and you suddenly see a revolution happening, it's very frightening because you think it could turn against gays in general, and who's to know where that would lead. We'd lived through the McCarthy era. I had very ambivalent feelings. I had, really, great admiration for the people who finally said, 'We're not going to take this anymore!' but I did feel threatened, and I thought, 'Now the whole thing's on the front page. Is this good or is this bad?'"

After he retired, though, the threat of being found out at work disappeared. "It was only afterwards that I realized that people knew anyway—but you play the game. And I felt I had to." Wednesday mornings when his cleaning help came, he felt underfoot, so he started wandering the neighborhood. Eventually he wandered into SAGE. It was a nice fit. He had been looking for more volunteer work, and he discovered that he had many old friends among SAGE's membership. He became active in the organization, but still, when family asked, he told them the "G" stood for Gray.

What he refers to as his "real coming out" was when Ken Dawson, the executive director of SAGE, managed to talk him into going on the Sally Jesse Raphael show. He supposed that no one he knew watched morning television. Wrong. The next day he got several congratulatory phone calls from family members, but his niece did interject a gentle remonstrance, something along the lines of "Why didn't you tell us?" And he said, "It's not a thing that's easy for me to talk about. I'm thinking of your kids, and I know their friends and their parents can be cruel. And she said to me, 'Uncle Adrian, that's not your problem, it's theirs.' And that was like the light dawning. So ever since then I've just decided, I am

who I am. I'm not walking around carrying a big banner, but I'm not hiding anymore. I'm right out there. I feel like I've been liberated. It's wonderful, absolutely wonderful."

Adrian lives alone. His apartment is designed with an eye for quiet elegance. This is not surprising for a man who is quietly elegant, in manner, in dress, in bearing. There is no clutter. It's comfortable. There are interesting things to touch. Lots of cookbooks. Lots of interests. And he has never lacked for sexual activity. "Right now I have this married man who's probably thirty years younger than I am, and I keep thinking that, if I were his age, I'd be looking for a much more exciting kind of person—well, physically exciting. And I also actually have three different people who call me all the time. One is younger, but not that much younger. The other one's twenty-five years younger, but he's Chinese and I think there's something about that culture that draws them to older people. I think I'm really very lucky—how nice to have this attention."

Adrian jokingly calls them "sperm buddies," going on to muse that "At this point in my life I'm not sure that I could handle a relationship. I've been living alone so long. I could if I had a lot of space, but I'm so used to doing my own thing. It takes a lot of discipline. But again, if somehow or other I met the right guy, I would certainly work at it."

Madelin and Renée

When Madelin hit fifty, she had a male therapist who kept telling her she ought to try women. Over the years, she had gotten quite proficient at brushing away such fantasies. She found them terrifying. It was somehow easier to imagine that her problem was just that she didn't know how to have a good relationship. But her therapist said that was like saying you won't go to Paris because you know you won't like it. So she talked to all her closest women friends, all of whom were "just marvelous." They weren't interested in it for themselves, but they were very supportive. "And one reminded me recently that she had offered herself to me if I wanted to experiment with her and was afraid to go with somebody I didn't know."

So Madelin "went to Paris, and discovered that it was just as hard to have a relationship with a woman as it was with a man, but there was something more appealing about it." Madelin is seventy-four and Renée is eighty. They met at SAGE eleven years ago. They proudly wear matching rings. They get together on Fridays and part on Sundays. They are obviously good friends, sweet and affectionate with each other. Renée says, "We each of us like alone time. This was the best way we could work it out. I know it's not ideal, but it's best for us." Whether it is or is

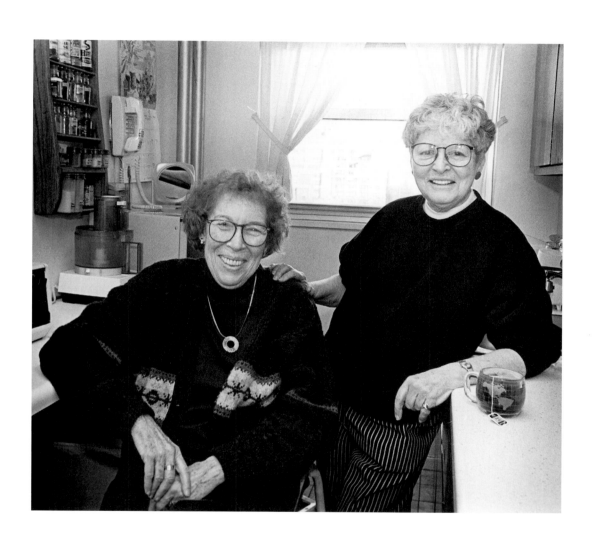

not ideal speaks to the standards against which we measure our lives, the anxiety produced by norms.

Madelin exudes competence and comfort. She is a tall woman who commands space and attention easily. She suspects that people look at her and think butch, but she certainly doesn't cultivate it. She likes feminine women who exude strength. Renée is quiet, a bit shy in her affect. She lets Madelin lead and cover in social situations. She is a very feminine woman. But she does think of herself as a butch—or at least a boy. "When I was a kid, I always thought that someday I'd grow up to be a fireman or a policeman and I'd save the maiden in distress." Then she says with amusement, "But what's a butch? It's the aggressive one, and she is more aggressive than I. But she thinks of herself as very feminine. She's much taller than I. She's got a more forceful personality than I have. One time we went to a Halloween party, and we dressed as Captain Hook and Peter Pan. Guess who was Captain Hook? I was. I was the butch, and she was a sweet little Peter Pan. It was very funny. But we knew it was funny. This whole butch/femme thing would be more comfortable if it were more clearly defined."

Renée had been out, at least to herself, since the fifties when she and her suburban business partner, Rhoda, invented a sexuality for which they had no name. They thought they were the only ones in the world. When they discovered lesbian pulp, the hot and fabulous stories both fanned and mirrored their feelings. But those stories always came embedded in a swamp of social agendas and moral directives that invited shame. The lesbian heroines all died or committed suicide or crawled back to men. Renée was married and the mother of three children. She was convinced that what she was doing must be wrong. It felt too good to renounce, but there was the constant guilt, and guilt can lead to some pretty bizarre behavior. Renée remembers how she would tear the covers

off lesbian romances when she was finished, throw the book out of the car, and then shred the covers. "Somehow" an identifiable fragment of cover ended up on the floor of her home. *He* found it. Says Renée, without irony, "Maybe this was subconsciously intentional." He accused: She is a criminal and he will have her declared an unfit mother. She will never see her children again—if she leaves him. He didn't threaten to leave her. He didn't even insist that she terminate her business partnership. He just used her guilt to enforce the trap and save face. And Renée bought it. "I was a criminal. I really was, because I was in a marriage. I had children."

Some people find that kind of victim an irresistible target. Unfortunately her girlfriend was one. She cheated Renée out of her half of their business and left. Renée was devastated. She went to Italy with her youngest child for a year, but was too lonely. She came home and her husband dropped dead of a heart attack. It must have been her fault. She sold everything and moved to the city to live out her life "in a box apartment and be a little black widow."

There were a few more abusive relationships, but Renée eventually found a therapist—and she found Madelin. "That was eleven years ago. If not for the therapist, it would not have lasted. I learned an awful lot about myself, and I think I have found the woman of my dreams."

The woman of her dreams had yet to refer to herself as a lesbian. Madelin had lost track of how many men she had had relationships with—or relations—or both. "I kept going out with men and having sex with men to prove that I was OK." Then something arrived mysteriously in the mail from SAGE. It went from the desk to the wastebasket and back several times before it went to the therapist, who encouraged her to try the rap group. "I knew all along. I mean, I have to say, bottom line, I knew. But it was so—it's a strong word, but it's the only word that keeps

coming to my mind—it was so repellent to me that I never could just say, 'This is who I am and there's a possibility of having an acceptable way of life, until I was in the SAGE rap group. In the rap group, I met so many great women, not all of them—some of them were real pains—but that's true in any group. And it didn't happen overnight. It took maybe a year, maybe two years before I could use the word lesbian."

In the course of these interviews the issue of marriage came up often. Most of the couples considered themselves married anyway, the legal prohibitions an annoyance and certainly a civil rights issue. Madelin had a slightly different take. It was thoughtful and revealing and probably more universal than acknowledged. "My first response when somebody said to me, 'What do you think about gay marriage?' was 'I think that's a good idea, legally. Everyone should have the same rights.' And then I thought about it more, and I realized that, for me, that was not really the fundamental issue. The fundamental issue for me had to do with the fact that, as a single woman, I've always felt that people looked at me as somebody who was not lovable, or not loved enough by somebody to get married. And conversely, I did not love deeply enough to commit to somebody else, that I was defective. That was my lifelong anguish. Marriage says: I'm not defective. And so that to me would be a more compelling reason to want to see it legalized. I don't personally need that sanction anymore. That is a wonderful thing that SAGE did for me. It validated me. It validated me as a person whose life is, and whose personhood is, just as important as anybody else's, even though I never married."

The shape of these two women's lives is very different, but the normed behaviors they tried so hard to wear comfortably took rather parallel tucks in their search for peace and joy. Madelin has a couple of degrees and several successful careers under her belt. She is an impres-

sive woman by anyone's standards. Renée has raised three children who love her, respect her, share her grandchildren with her. She went back to college at fifty-five and got a degree, a new career as an X-ray technologist, and "a sense of ego that I never had before." These are educated women, successful women, thoughtful women who have done a lot of work in the world and on themselves. It took them a long time to get to a place of comfort. Renée says, "I feel easier now because I've accepted myself." Madelin still says, "Being out to myself has been very difficult and very long in coming, and I'm not sure that it's all clear yet."

Hank/Helena

"I have not had anyone in the medical profession admit that bisexuality exists. They all told me there was no such thing. I'm either gay, or heterosexual, or I'm oversexed. And so that's what I thought, that I was oversexed. Because when I was with a woman, I also wanted a man. And when I was with a man, I also wanted a woman. I never realized until now that I wanted to have sex every night because I was searching for that missing thing. So I've been through alcohol, I've been through gambling, I've been through cocaine, I've been a workaholic, and I've been in therapy for over twenty-five years."

Finally, two years ago, Hank found a therapist who gave him permission. She said, "You call yourself a free spirit. Do it!" Tentatively, he began gathering the female things he coveted. At first he experimented in private, but more recently, as his wardrobe and his self-confidence have grown, she ventures out in public. Feeding her appetite for the fabulous and forbidden is delicious fun. "I'm going on sixty-three, and my life is just beginning. I'm not a misfit. I'm not who I am because of anger. I've worked hard all my life. And I've worked hard in therapy. I'm happier more each day with who I am."

The woman Hank is choosing to become calls herself Helena. It was

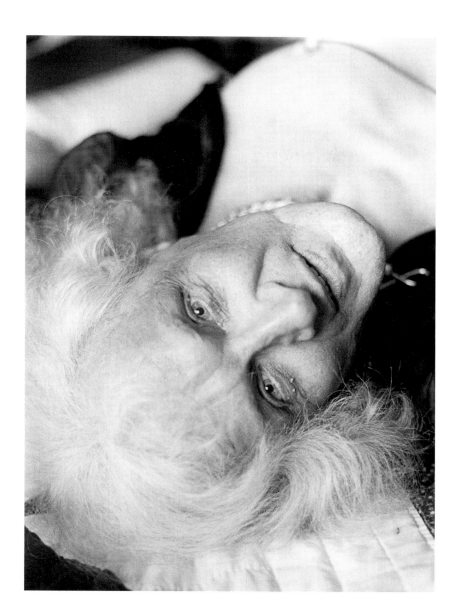

Helena who was feeding the birds on the lawn of her apartment in Queens Village when I arrived. It was an exuberant dance of arabesques and flying masses of white—no, she corrects me, platinum—hair. But then it was Hank who tucked his wild locks into a semblance of order, squared his shoulders, and shook my hand firmly before leading me upstairs to a home that is clearly shared space. The kitchen and living room might be any temporary bachelor quarters. They are spare and neat, and not fully unpacked. Records lie in piles on the floor fronting a wall lined with boxes and a few austerely framed diplomas. But the bedroom is overwhelmed by a huge four-poster bed, draped heavily with black velvet. The coverlet is taut, white Americana, and on the deep pillows perch a demure family of soft pets. Girlish flimsies hang from the posts, fetchingly disguised as laundry, and a closet door, casually ajar, invites a peek at rows of dangerous stiletto heels and sequined scarves.

Hank makes coffee and sits down to talk—about education and politics and war. He is a thoughtful, articulate conversationalist whose stories reveal a lifetime of activism and commitment to labor issues, workers' rights, and civil liberties. But then Helena gets impatient, has to interrupt. His face morphs into hers, and she smiles at me with seductive complicity. She is quite sure I would rather talk about sex and joy and other kinds of possibility. He says, batting her away with gentle amusement, that she is becoming more insistent all the time. He is not quite sure yet how she will be received, and there is something of the new parent in his protective posturing. But by the time I reach for my camera, he has clearly decided to let her have her way. Hank takes his leave and Helena begs a moment to slip into something a little more comfortable. The photographs are all hers.

Between his drunken, abusive father who couldn't keep a job and a

mother out of a Grimm fairy tale, Hank's childhood was a nightmare. "There were seven children and not enough love for one. My mother told me I should never have been born, but being that I was, I owed her." He sold papers after school from seven at night until one or two in the morning. Bigger kids would try to rob him, and he got a reputation for being, if not particularly strong, then absolutely fierce. His mother used to wait up for him to demand his earnings, even searching his pockets for hidden change. Hank kept hawking papers less for the coins he could squirrel away than to be out of the house, away from the belts and the brooms. When he was ten, he was raped by a man in Prospect Park on his way home from sledding. He had borrowed his sister's Flexible Flier, and all he remembers thinking at the time was what his mother would do to him if the guy stole the sled. He never told a soul. It was, he says, his "secret for forty years, and it still hurts, terribly, after fifty."

Hank's litany of sadness continued into adulthood. He tried marriage once and other relationships, both hetero- and homosexual. But nothing felt right. He was so miserable that, when the Vietnam War broke out, he signed up for a second tour of duty. His brother's version of the story is that Hank signed up so that he wouldn't have to go. Hank says, sure, "I wanted to save one person from going." But he also admits that "going was suicide," a search for "some kind of honorable death."

Instead he has had an honorable life. He has worked hard for the phone company for thirty years. He was repeatedly elected shop steward and chief steward for his local, Local 1101 of the Communication Workers of America, and he was always the guy who stood up to bigots and racists, bullies of any kind. He went back to school at forty-seven years of age to get a degree in labor studies, followed by a master's degree in special education. When the war in Nicaragua began, Hank started

spending all his vacations there, doing what he could to support the Sandinistas. His politics angered the more conservative union hierarchy and he was "decertified" as a shop steward. He is still a dues-paying member of the union with a reputation as a scrappy defender of everyone else's civil rights, but Hank himself is afraid of people's judgment. Helena doesn't care.

Helena is a new member of the Imperial Queens and Kings of Greater New York and the Cross Dressers International. She goes out dancing most Saturday nights, dressed to kill. She likes the Silver Swan and other transgender-friendly dance places. "I go in there and dance and people watch me because I dance very well. I use the whole floor. I'm like a Broadway show. I just love it that I went to a debutante ball! Instead of hiding my femininity I am bringing it out." Her closet is filled with fantastic six-inch retro-dagger heels, fabulous platinum wigs, and sequined gowns. She wears false breasts and panty hose, but her real delight is the panties. "I love them. I can't take them off. They feel so good. I mean, what do *we* get? Fruit of the Loom." Even she has trouble with the pronouns.

In two years, she figures, she will be able to afford plastic surgery on her face, and then, who knows? Perhaps something more radical. "I am still out there searching. I am still looking for what I am, who I am. I think I am looking to be a woman. I want to be a woman, a lesbian woman. I don't trust men to understand intimacy, but as a woman maybe I could find someone I could love, someone who would love and understand me for who I am."

"As a man," Hank says, "I am always on, always protecting myself. I am afraid my femininity will show. Not being masculine in our penis-oriented society is like being a scab in a powerful union." Hank looks

forward to the day when Helena will care more about Nicaragua. She is, he says, "still growing." But she offers him important freedoms. To be her, to be a woman, is to "feel free to cry. I want to be beautiful. I want to be loved, adored, and seduced. I want to be a bitch at times. I want to dance, and I love when my hair blows in the wind."

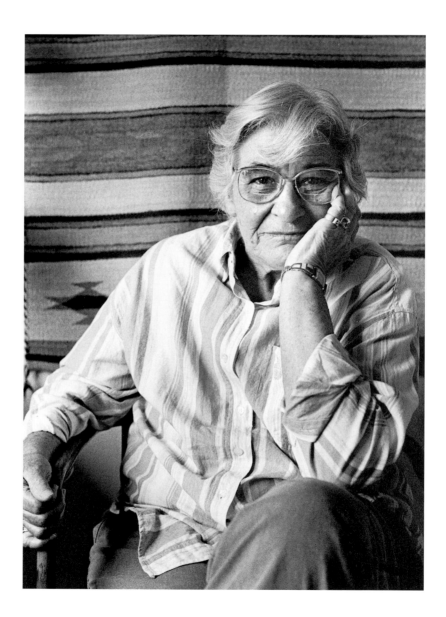

Jerre

"I grew up in the South Bronx, and it was hard, especially when I was all twisted. I looked so masculine. I had this very short hair-cut and wore a man's shirt. I couldn't, I couldn't carry a purse. When I had to get my first job, I had a paper bag and my comb and my wallet and everything was in there. At that time, on the 3rd avenue El, you paid your nickel, you went right through the turnstile, and the bath-rooms were right there. I went in, and a man left the change booth to come in and say, 'What are you doing in the ladies' room, sonny?' That's how masculine I looked. I mean, it was terrible. It hurt so, not to be able to be like anybody else. I didn't know what I was! I didn't know what was happening."

Jerre is almost eighty now. She lives alone, perhaps too alone. She is a strong woman, broad-shouldered, casually dressed in tailored shirts and jeans. Her hair is still cut short, but soft and silver. She herself is rather soft, tentative, a little skittish. For such a powerful woman, she has an air of frailty. As if she is expecting to be hit.

She has been hit a lot. She loved her father, but he was a drunk. She used a baseball bat to protect her mother. He beat her when she played with boys, but taught her to box and wrestle so she could protect her

sickly kid brother. She was left back five different times in school with undiagnosed dyslexia. She was yelled at for wasting electricity when she tried to study. The art projects that were her joy were offhandedly dismissed. It seemed she couldn't do anything right.

Enter the aunts. She kissed them and suddenly she was being fussed over. The Kiss! They complimented her on her style. Compared it to Hollywood. "So I went around kissing girls! I mean, this was the only thing I was doing well at! It was very sad, kind of. But I made my own happiness, you know, by being with women."

Jerre is delightfully candid talking about her life. She laces her stories with details about sexual adventures and experimentation, but then shy kicks in: Please don't write that. And she is protective and loyal, anxious someone else might be identifiable in a vignette, someone who might still be hurt by exposure. Too many things make her anxious; too many things hurt. She argues with herself a lot about what she should be doing now, but she enjoys her memories, enjoys their richness. And she loves to tell stories.

At thirteen, she found Marge and Bobbe. There was no sex between them. They were three pals, three butches, and they liked girls, femmes. But sitting around somebody's kitchen table talking in coded language when a mother might be listening, the girls were "passion flowers." The three of them were "butch beans." "We were gay then, at thirteen!" Jerre seduced her first passion flower by giving her a copy of *The Well of Loneliness*. She was invited to demonstrate her prowess with The Kiss, but privacy was hard to come by when everybody was still living at home and the fear of exposure was constant. Jerre came up with an ingenious solution: the platforms at Penn Station and Grand Central offered perfect camouflage. They could pretend that one or the other was leaving, and a

kiss, even a passionate one, was hardly noticed. They even worked the subways, parting and coming together at the various stops on the line.

Jerre stayed at home protecting her mother until she was twenty-two, but when her mother died, she moved out to begin "living the life I wanted to live." Her first real love was a dancer, an older woman who looked like Gertrude Lawrence and who taught her how to dress, how not to "walk like a truck driver," and that there was more to lesbian sex than kissing standing up. Jerre was very much in love, but they broke up when she sensed that her partner wasn't being faithful. Fidelity was important to her.

Mostly her relationships were short-lived. She loved sex. She had good friends. She liked the bar scene. "We used to close the bars at four in the morning and be able to walk the streets. We used to meet Eleanor Roosevelt in Washington Square Park with Fala, and she would say, 'Good morning, ladies.' I mean it was just wonderful! It was wonderful!" The bars were rarely raided. When they were, the cops pretty much left the women alone. "I think they just thought we were . . . we were just playing!"

The play stopped abruptly in 1969. Her large breasts had been a source of acute discomfort in her youth. They contradicted her self-image. "I used to wear sweaters and bind myself and everything because I was so athletic and masculine. And when I went to bed with women, I always wore a top piece." But her breasts were something she had learned to accept, and suddenly at fifty they threatened her life. She had a double mastectomy twenty-eight years ago, and that, in many ways, has been more isolating than her homosexuality ever was.

"Well, you see what happened, why I haven't had sex in all this time, in over twenty years, is my cancer operation was in 1969. Women

were not out with this at all. I was going to bars. I was picking up people, but I couldn't take anyone home without telling them. So I would tell, and the first thing they would do was look at my chest, and of course I was wearing the prosthesis, and everything changed. The conversation changed. They weren't coming home with me. It was over. I realized many years later, 'Damn fool! Just get to know the person. You don't have to tell them the first night. Just get to know them, and they get to know you, and then it would be a better chance.' But I didn't do it that way, and I guess word of mouth got around. People were saying, 'She has breast cancer.' At that time, people were saying it undercover. It wasn't out in the open. My chances just disappeared. So I said, 'To hell with this!' I guess I was rejected. You think, 'Well, you're not attractive anymore, and you've gotten heavier.' And, well, I never thought I was attractive to begin with. And yet, I just realize now when I look at some of the pictures, God, you know, I was really a good-looking butch. Now I meet people in the street who don't believe I'm seventy-eight. I meet people from years ago, and they say, 'You haven't changed at all.' I see I have, of course. Your body has changes. I mean, the triple hernia scar which is like this, and the breast cancer one which is like this, and then they had to do the ovaries. It's like this. And now the hip. I have the other one to go. So I have a V, a V for victory!"

Jerre went to the second meeting of SAGE in 1978 and has been going ever since. She has found a new community of friends and a voice she never thought she had. She now insists on respect in hardware stores where clerks see her gray hair and tell her she doesn't want what she wants. "'What is it? Is it because my hair is gray and you don't think I know what I'm talking about? Or that I'm a woman? I had my own machine shop!' That's what I mean when I say I stand up for my rights

now. I'm getting angry. I've been angry before, but I didn't know how to really talk. I guess I'm not as shy as I was."

Jerre is a survivor. She has always tried to make the best of a hand that held some good and some really rotten cards. She would have loved to have gone to college. Her dyslexia made that an unrealistic dream, and her job options have always been limited. Her cancer left her feeling horribly mutilated and, in the climate of the times, even contagious. She's afraid to make much of an effort over people. She has lost too many friends lately. She has no money, a body that continues to let her down, and she is often lonely. But one minute this feisty woman is saying "I can't do it anymore. I guess I'm getting too weak. You know, I'm seventy-eight myself." And the next she is arguing with her own demons: "Maybe I'm not out enough. I'm just on my own most of the time. I'm getting the urge to go to a bar, whether I can afford it or not, just to be around people again. I always meet people and talk and have a great day. But I like to drink when I'm there, and who can afford it? And being a waitress all my life, you don't leave without tipping. You just don't."

This woman has real heart and real trouble. She is torn. Her parting shot reveals how hard she is trying to talk herself into venturing out into a landscape that is strange and not a little frightening. "I'm concerned, sexually. I don't know what care has to be taken in relationships with women. I'm a little uptight about AIDS, and I have not gone anyplace to learn about the dentist things—yeah, the dams. But, you know, I made eye contact in the street when I was out today. I'm getting back in the swing again, as far as women go."

Myron

Try getting into Myron's apartment. If you're a pound or two heavier than he is, you'll never make it through the front door opening. If you make it through the door, you would do well to avoid the cat litter box that blocks it from behind. Proceed with caution down a hallway piled chest-high with precariously balanced stacks of newspapers, magazines, and manuscripts. Avalanche is an ever-present danger, and Myron leads the way, muttering apologies and warnings, and tossing obstacles to left and right like a snowplow.

You will now have reached what remains of the living area. Cliffs of accretion soar to the ceiling: vacuum cleaners and phones, coats, books and fans, posters, pamphlets, and hundreds of pill bottles. Myron climbs over a chair, tosses its contents toward the top of the pile, and gestures for me to follow. He excavates a folding chair from somewhere and places it facing mine so our knees are touching. We are apparently ready to begin.

Myron is an HIV-positive man and an AIDS activist. He has recently been appointed to the mayor's planning council for AIDS, and claims to be both welcome and not on dozens of other boards throughout the city. He is a man who has found his calling, unfailing in his energetic

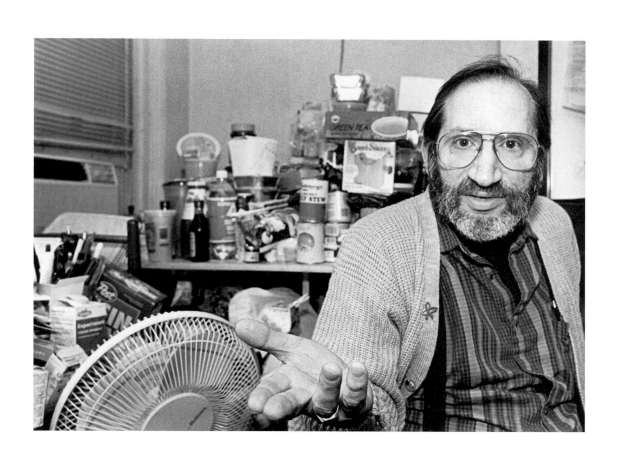

pursuit of attention, a natural lobbyist and a political animal. He loves this stuff, collects facts and statistics like his fans and his phones, and gestures expansively with both hands when he delivers an opinion. He is a bit like the White Rabbit: so little time; so much to do.

Myron opens with a flourish, a Clinton tirade with a neat twist: "You hear about this man's penis on television for twelve months! You hear about the blow jobs! $156 million for AIDS prevention, but was this man practicing safe sex? Was he wearing a condom? What kind of an example is that!" Once Myron is out of the gate it is hard to get a word in. He never really answers a question, jumps from one idea to another, and speaks in acronyms. Most of his opinions are prefaced by a list of the people of note who have been obliged to take them seriously. He can spew a sound bite on just about anything that has to do with AIDS. He is proud of his reputation as a gadfly and a pain in the neck. He knows he is on the right side, and if people find him annoying, it is because he is doing his job well.

Myron has lived in this one-room apartment for most of his adult life. He admits to having a somewhat strained relationship with the landlord, who indulges banal concerns about fire laws and other such nonsense. Myron brushes the thought away. He simply has too much to do to be bothered with such niceties. His work is what impassions him, and he is involved in so many more compelling issues. He has far too much energy for such a small space.

His story, in many respects, is not uncommon. He was seduced by Eddie when he was fifteen, and the experience was a revelation. He immediately abandoned all hope of pleasing his parents or his girlfriends. Instead, he started dating his sister's boyfriend. The family sent him to a psychiatrist. The psychiatrist seduced him. When it became too difficult to live at home, he moved in with Eddie. He started at City College in

Civil Engineering, but quickly switched to the Fashion Institute of Technology, better known as FIT, or according to Myron, Faggots in Training. "Bridges, clothes, I was still a designer." His relationship lasted for five difficult years; Eddie was both "sexually insatiable" and painfully unfaithful. "So," Myron explains, "the rest of my life has been one-night flings."

Myron refers to himself as a "graduate of every bathhouse" in New York. He and an Italian friend went every Saturday night. The Continental was their favorite because Bette Midler and Barry Manilow were the entertainment. And he has a Mineshaft T-shirt he wants to show me. "It's here somewhere." I imagine about thirty years down.

In 1981, his Italian friend got sick. "It was a strange illness which no one at that time even called GRID. He had lesions all over, his penis, his ass, his feet, his toes. Everywhere. On his nose. That's what he was most upset about. He kept putting make-up on trying to hide it. Every night after work, I'd drive to Brooklyn to make sure he had dinner and I'd wash him and then go home to the city. Every day for a year and a half. And that's another thing!" Myron pokes at the air in anger and frustration. "I had to bring this up to the Health Department. When he went to the hospital, no one would touch him. He would be lying in vomit. Everyone was scared." And then he shrinks a little, remembering the day he came and his friend "was in very bad condition. He died while I was there. No death has hit me that hard. And little did I know what was coming for me."

If Myron was hurt by his friend's death, he was undeterred. "I was being tested three times a year because of my lifestyle. Always negative. Then all of a sudden in 1993, I got sick. My white blood count was 800. They tested me for two weeks and finally the HIV social worker at the hospital comes into the room, full of people, and yells out to me, 'My-

ron, you're positive.' There goes your confidentiality, out the window, and your dignity. I had had what you call an acute sero-conversion. I was sick from day one. I left the hospital walking with a cane."

It's been five years. Myron says he has been through forty illnesses and takes fifty pills a day now, but it really makes him frantic (and the advocate mad) that he can find no studies or statistics on HIV and aging. "Even the biggest doctors, they don't want to talk about that—the relationship of HIV medication and aging medication. I'm taking heart medications and pain medications and HIV medications and no one knows."

"Plus, I have to deal with this senior citizen business. When I come to the GMHC I get 'There's the old man.' All these young kids. They don't even know about Stonewall. They don't know the first thing about what we did."

Myron's life has piled up around him, like his stuff. He has such a narrow space to live in. He is proud of the lobbying he has done for domestic partnership legislation, the Patient's Bill of Rights, drug rehabilitation and needle exchange programs, but he can't manage the mess that Social Security and Medicaid make of his benefits. He gets too much money from SSD to get Medicaid benefits. But that is before he pays his pharmacy bills. So every month Medicaid cancels him, only to reinstate his eligibility when he shows them his pharmacy receipts. That often means standing in line for six hours. They shut off his food stamps for the same reason, and he has not yet managed to get those back.

So much to do; so little time. Myron is a man possessed. "I used to get depressed before I was ill, when I was still working as a designer. But, that's the strangest thing. Since I became ill, since I retired, I don't have time to be depressed. I'm so busy I can't even think about that." A phone is ringing, but first it must be found. Atop an aerie of clutter, near

the ceiling, an unnaturally large cat lounges, smiling a Cheshire smile. "Forty pounds." Myron offers cat statistics, while scrambling for the phone. I take a deep breath and feel not a little like Alice, who, as Lewis Carol said, "was not much surprised at this, she was getting so well used to queer things happening."

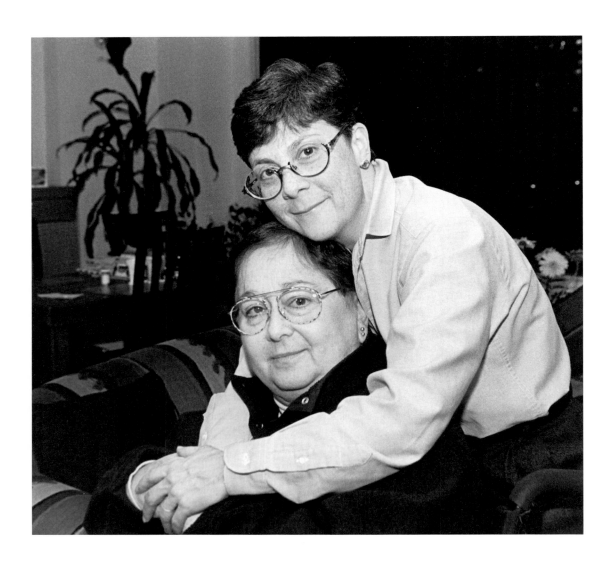

Jane and Bette

Jane says, "I am not sure I even belong in this project, my experience is so atypical. I was a virgin at forty. But I found Bette and that was all. I knew that it was right. I believe that sometimes there is just one person right for you. I've got mine. I have never lain with any one except my Bette." Now Jane is sixty-one. Bette is fifty. For twenty-one years they have shared a carefully circumscribed haven of emotional security and solidity. They have protected that world fiercely. Jealousy has been indulged between them as a reminder of how precious it is.

Jane is now in a wheelchair. She has endured a series of life-threatening illnesses that have left her overweight, her legs and feet dangerously swollen, and in constant pain. She says she looks like "an old and sickly lady" when she sees herself in pictures. Otherwise, she is emphatically "fine." It is ironic that the carefully constructed safety of their exclusive little world has been invaded from within. The jealousies are still voiced, but now they are more like mantras, like vows, like promises. Jane, currently stuck in her chair, with her pain and her fear and a twenty-one-year shared history, teases Bette with threats to go "sow my wild oats." Bette says, "You want to go sow some wild oats, I'll kill you!" Jane says, "Well, that takes care of that!"

But of course it doesn't, and Jane has developed an endearing affect that is almost a child's plea, begging the world to be the safe place she would so like it to be. She flirts. The firemen who rescued her and her scooter from the city bus when its lift broke were all "adorable, each one." Her doctor is "an adorable little teddy bear of a guy." But mostly her Bette is "absolutely adorable." The world is not a soft and cuddly place. She has the scars to prove it, but she flirts a bit like a puppy, hoping.

When Jane got her first chair, Bette insisted it not be motorized. "I insisted upon being participatory. I would not allow her to get a scooter or an electric wheelchair. I had to be the one to power her. I wanted her to know that I was behind her and supportive, and that was a real physical way of doing it. And I also wanted to maintain a connection I felt I would lose in some way if she was motorized. It was great for a while until my body began to fail. And it was very important. We went places together. Somehow we never felt it was going to be for the long term. It was just a real temporary thing, so it was OK. Then of course it became a little clearer that this was not for the short haul and could perhaps be for a very long time. So then I gave way to the necessity for her independence. That's when she decided on the scooter, which was really about her connection to the outside world. She had shut herself in, or rather the world had shut itself away from her. She couldn't get around on her own. And now she's got the scooter."

Neither of these women had comfortable early lives. They both had troubled families and were intimate with otherness. Jane went to high school at twelve and to college at sixteen. She decided that sexuality was something she wouldn't have to deal with until she grew up. When that finally happened—at forty—she came out immediately and with enthusiasm, perhaps even bravada, in every aspect of her life. When her par-

ents threatened to disown her, she howled back at them, "Listen, what more do you want. She's a nice Jewish professional."

Bette began her first long-term relationship with another woman at age thirteen. "It just seemed so natural." Coming out, however, was a long and painful process for her, only realized some six years ago when it became clear that Jane's health problems would be easier to manage if her employer understood the nature of their relationship. They are now registered domestic partners. They were "on the steps" that morning in 1993 when the city inaugurated its policy. They went with another couple and their friend Bruce, who was flower girl for both couples. So they share an anniversary, I suspect, with a fairly large number of New Yorkers. But being registered domestic partners is small comfort when Jane has to go out of state for various surgical procedures and no one is clear about what, if any, status their New York papers will afford Bette.

Bette and Jane have chosen an insular life style. Jane says they are both voyeurs, preferring to watch rather than participate. But their insularity, in the face of Jane's illness, is problematic. "From the beginning of our relationship, I was very aware of how much older I was than her and that I already had a disease that would probably kill me if nothing else would. I was always very protective and wanted her to have a circle of friends. For her, I was enough. And we certainly were extremely happy with each other. We do not need other people to complete our circle. For her, there's me. And that's fine. Single people were out. It was dangerous. So couples were the thing. It was hard to meet couples." For a while, they joined a SAGE group for monogamous couples. It afforded them some important friendships, but the group fell apart, and Jane is still concerned about Bette after she is gone. Bette says she is planning to re-engage in community. She used to be a political activist before they met. Now she is talking about what she would like to be looking forward to,

the world she would like to be getting old in, and the ways she thinks she can help that happen: "I think there's a whole group of lesbians out there, and gay men, who are established in their business lives, who are not afraid to be out and who are willing to take a step, to speak up with other than their checkbook, and I want that. I want someone to listen, and I want to listen, and I want to participate in a growing community, and I want to stay there comfortably, not have to lie and say we're spinsters, we're widows. We are who we are. I want to know there's going to be a Sun City for me to go to with Jane. . . ."

Job and Robert

These two, in their complementary plaid shirts, make a big deal about combing each other's hair before letting me take pictures. I am directed to make certain that under no circumstances is Job to appear to be the taller of the two. Apparently that happened once. I am not worried. Robert must be a foot taller and has to lean way down to be fussed over. Job has less to comb. He is eighty-one. Robert is eighty-six. Thirty-one years ago they spent an evening together in the West Side YMCA. Neither was looking for "Mr. Right—just a better evening." But that was it. You don't always get what you're looking for.

They are well read, cultured, articulate, and very funny. Robert was a successful landscape architect. Job, a milliner by avocation, earned his living lining boxes and cabinets for the affluent when he wasn't working at a hotel front desk for money. Robert was closeted all his life until he joined SAGE. Job never advertised, but also never hid.

They are gentle with each other. They take time making sure the other is comfortable, considered. They will not be interviewed separately. Yet it is not an obvious match. Robert is loose in his body. He hunches a bit when he walks, chin down, so his easy grin peeks from under one cocked eyebrow. Job's body exudes a kind of muscular rigidity that

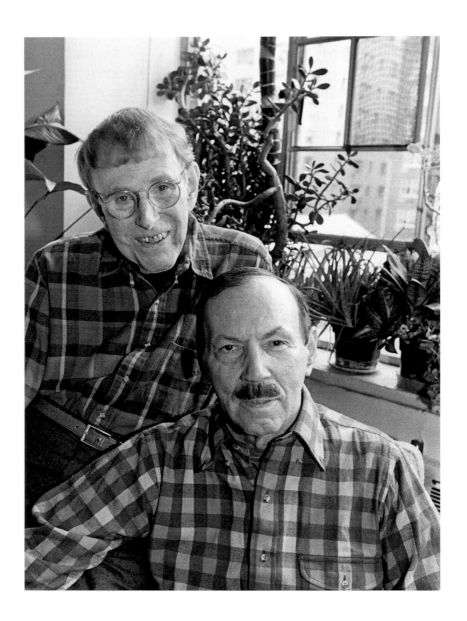

makes smiling seem difficult and his uninflected, startlingly sharp humor both a surprise and a delight. Robert is the practical one, or at least the one who describes his life choices in terms of practicalities. Job talks about his feelings.

During Robert's last year in college, he saw a therapist five days a week. He remembers that it was "like peeling off skin, very painful, but very illuminating." What the process revealed was an explanation for the "instinctive attractions" he had so far denied. The therapist convinced him that he could simply be reeducated to more "natural" proclivities, and he did manage what he calls "a butch way" for a number of years. Relatively butch, anyway. He worked in the mountains in Washington and fought fires in Idaho, "climbed Mount Hood nine times because there wasn't anything else to do," but, after he was drafted, he remembers being questioned by an underling in the army about the funny way his telephone smelled. Who knew that the Chanel might linger after he had gone?

Robert came from educated people. After the war, he found himself in New York, drawn by the culture as much as the job possibilities, but still "not knowing a gay man from a straight man." His community was straight and upscale. He liked to hang with the Northeast Harbor, Newport set. He dated women, but when a friend's mother suggested that he marry her daughter, he hid the reason why he could not. He was "not going to let her diagnose" him. He never told his parents, though he was very close to his mother. He never discussed his personal life with anyone. It was a private affair, and he learned to cruise. He doesn't remember his first sexual experience, but he remembers discovering areas like Riverside Drive and later scenes like the standing-room line at the Opera. He learned as he went, and he learned alone. "I didn't know enough about it to know what I was looking for exactly, except I wanted the

physical experience." He refers to his wanderings as "just a matter-of-fact necessity. They were merely part of my private world, my private enterprise, which I was motivated to do. I never felt I was part of the gay community because I was out looking for individuals. It wasn't community business, as far as I was concerned, and I never had much conversation with anybody about gay community. It was merely about physical encounter—and rarely about a repeat."

If Robert speaks of his sexual past in terms of necessity, practicality, and privacy, Job makes his sound more like a visit to a candy store. He was an early bloomer. He refers to himself as "an effeminate child, always different." By the time he was twelve, his parents recognized that he was "highly motivated" in pursuit of his desires, but the constant "love bites on his neck" that provided the clues also made them too nervous to broach the subject. He learned to make his own choices. He took sewing classes in college, the only man in a class of women. He liked working with his hands. The teacher tried to flunk him. She found him aberrant. He found her a momentary obstacle.

Until he met Robert, Job always maintained a membership in the YMCA. "Being self-employed and a morning person, I could go for a swim in the morning and see what I was going to get later in the day. I had no trouble recognizing other gay men. I suppose it was mostly instinct, though in the shower you get a pretty clear picture." Job always lived with men, and he chose careers and communities where he would not be compromised by or questioned about his life choices. He didn't have to tell what was hardly a secret.

Job had had a fifteen-year relationship with a man that ended in death. He was devastated. Robert lived with a man for six years, but his own simultaneous pursuit of other "rewarding partners" took a toll on the relationship. When his partner lost interest in sex, Robert asked him

to leave, but he remembers weeping "like a child." What he took from the experience was "pain—and the fact that you can't really depend on anybody." It was a lesson he lived by for the next twenty years, until he met Job. Neither expected or sought what they discovered in each other.

They have been monogamous throughout their three decades together. Job says Robert came to understand that "it wasn't just sex, it was a lot more than that." Robert waves that away. It was all about "very practical considerations." So Job says, "Well, for the first twenty years it was sex and money kept us together. The last ten years . . . " "Habit," says Robert. "And good meals," Job adds. "I think," he continues, "we made it for this period because we kept it varied and interesting. In the fifteen years that I have been sixty-five, I have joined ten senior citizen's organizations and gotten tickets and gone swimming, and now am taking arthritis classes while he sleeps. But we go to the theater, on and off Broadway, and Carnegie Hall and Avery Fischer Hall for a dollar or two dollars . . . " "Where he sleeps," says Robert.

If these two are unlikely as a couple, they have certainly learned to accommodate each other and a changing world. Job is a morning person, Robert a night person. The hours Robert chooses to keep mean they eat at such odd times that they find it difficult to eat in restaurants. They number their meals to indicate the absence of correlation between the words others use and their lived reality. When accused of being accommodating, Job shrugs and says, "Some people are worth it." Robert explains that the compliment might be motivated by "a vague awareness that I might be . . . be gone quite easily." Job says he is more than vaguely aware. They never used to hold hands on the street, but Job feels he can be a bit more public these days. "We hold on to each other due to his growing inability to see what used to be obvious. Because it's important that he knows that there is a half step there." While I was with them, they never let go.

Howard

Leaning forward seductively into my space, the way Howard always talks, sweeping long elegant fingers extended with an ever-present cigarette and using the smoke like a hint of Dietrich and mystery, Howard confides, "I have a bad reputation at SAGE . . . for being a sexually promiscuous person, and I—no, this is true!—all because of my friend Dick Hallot, who is a true friend—he's since died—and he used to kid me a lot, always sit at the table with me and call me old whore and things like that in front of these other people, and I think maybe they just got the idea—maybe she *is* an old broken-down bitch! And now a lot of them come over and greet me that way as if I'm still going strong. God knows I'd like it! So, I've made up my own club—the BDOB Club. You have to be over eighty years old to belong to it—the Broken Down Old Bitch Club."

Howard is delicate and small, characteristics exaggerated by the toll age and illness have taken on an originally slight frame. He talks with his hands, yes, but there is also a lot of eye, eyelash, and a patter that manages to be quietly flirtatious and a little naughty, even about frequent trips to the "la la." He is eighty-five, and though his body language is still pure seduction, the body that speaks has seen better days.

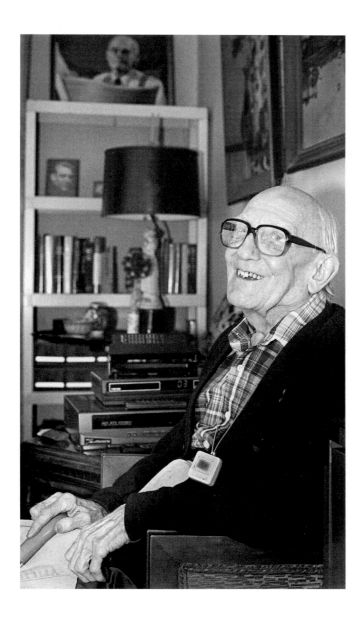

He presented me with a risqué little image of himself posing as mock-odalisque, draped on a bed in boxers covered with Valentine hearts. His body is very white, very bony, swimming in the underwear. His wrist is behind his head. His eyes are hooded, alluring. His socks are black and probably warm. It is classic Howard: pure camp humor and deliciously sexual self-mockery.

In 1945, Howard went to a bottle party at a friend's house. He was captivated by a man with beautiful gray hair, and remembers the line he used to introduce himself. "Isn't this the dance you promised me?" "I don't dance," said Grant and walked away. But Howard was not deterred, and by the end of the evening they were a couple. "Grant really didn't like to dance at all. But he had other lovable things that made life with him for thirty-eight years wonderful. Mmm hmmm."

They were a devoted couple, but Howard bridles at the suggestion that their lives were sedate. Grant was an artist, and together they adorned their living spaces with exotically colored walls and frequently re-dyed flamboyant draperies. Howard's walls now are covered with Grant's paintings, including a portrait of Howard's father at eighty-six that might easily be him. Howard worked on Wall Street, "in a cage," but he had obvious style, and his boss used to ask his advice on issues of decor and compliment him on the feminine touch he contributed to the office. He and Grant always did the Saturday night bird circuit: "You know, bars like the Flamingo, and the Bird of Paradise, and I think there was one that was the Cockatoo. They all had a bird's name, and they were all known for being gay. And I think, because they were known for being gay, it was kind of safe—nobody bothered you." Howard jokes about defending his honor in "johns" with his beaded bag and on the streets with his "butch walk—butch spelled with an 'i.'" He got away with a lot. "Quite often we'd hold hands when we walked, but—all of

this sounds awfully boasting to you—but I wasn't afraid of things. Maybe it's because I'm so big and brawny. I didn't think it was going to happen to me. I couldn't understand why it would happen to me—and it didn't happen."

Howard says he knew he was gay three days after he was born. He always admired men and never felt he had to hide his admiration, but he never actually told his parents, or anyone else for that matter. He describes it this way: "My father loved Grant dearly, as did my mother. I don't think my father understood, I really don't. But if he did, he never made any big fuss or anything like that. And my mother adored Grant. My mother was a very open-minded person. She always wanted to be an actress. My brother must have known that Grant and I were gay. He was an actor—he understood all those things. None of my family ever censured me in any way. Oh, all the gay people that I brought to the house, well, some of them, were a little bit on the swishy side, but all of them liked to cook or bake or do things like that, and they'd get in long conversations with my mother, and I didn't have to say anything. She had a wonderful time with them!"

Two of Howard's oldest and best friends, Perry and Jim, had a house in Virginia where he used to visit. In all the years they were friends, they never discussed the fact that they were all gay. "It was never mentioned. But I remember after Grant died, and I was down there, Perry said to me, 'How long did you live with Grant?' and I said, 'Thirty-eight years.' And he said, 'My God, that's longer than most marriages!' Now, I know Perry and Jim were gay, but it was never mentioned, ever. They never said anything and I never said anything to them, and it was just accepted. No, I don't think it was closeted. I think they felt the same way that I felt: It's none of your business. So why? If we're happy talking about other things, why say, 'Girl, listen!' which some of the girls say, which is un-

necessary. I don't think I was ashamed of it, but I saw no reason ever to say it to people. And nobody asked me, so, what is the difference? Oh, I couldn't talk without my hands, could I?"

Nothing was ever discussed, but at the same time nothing was hidden or denied. Everything was said with hands and eyes and inflection—body language. It was Howard's way of being completely seen without being confrontational or hurtful. It allowed people to ignore the obvious if they so chose, if it made them uncomfortable, but it also was a most effective way of acknowledging the currency of homophobic attitudes and refusing to truck with them. It was his way of saying "If there's a problem, it's yours, not mine."

"Maybe I was always queer," he says, "but I don't think I was different. I think there will always be lots and lots of people just like me. I wish the people that are young now, younger people who are gay, would have the confidence that I had. Where I got it from I don't know. I just wasn't afraid. Maybe that's what protected me. Maybe I didn't project fear. I don't know what it was. I wasn't afraid and people never bothered me. You figure it out. I can't."

Connie and Phyllis

I said, "Connie, I want this project to yell back at those family values folks who claim we stain the social fabric and subvert the social contract." Connie is a little impatient with me. I am missing the point, starting in the middle. "I'd rather wrestle Newt Gingrich to the ground and find out where his shirts are made!" she chides. "I'd rather answer by saying, 'What kind of family values do these people have who don't care about child labor and don't care about people having jobs!'" Connie is getting her teeth into this one. I have given her a lead she can really run with. "I mean, there are many struggles. Gay and lesbian rights are certainly way up there, but I think I encompass it under a larger heading called Defeating Fascism, which I believe threatens all of the rights that I care about as a lesbian, as a Jew, as a woman, as a trade unionist. I believe very strongly in the right to criticize and the right to dissent, and I want to know how many thousands of years will it be before there's no place else to go to get some kid to make your shirts."

Connie is a small woman, maybe 5'2", but she has the presence of a bantam hen, if there is such a thing, a fighting hen, and she says she drives her friends crazy going on about where their clothes were made. She is scrappy, feisty, looking to teach, looking to argue, and absolutely

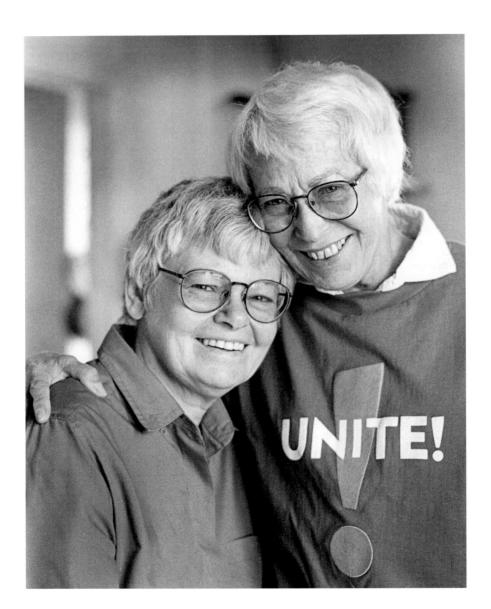

willing to be dismissed as a pain in the neck rather than forgo raising an uncomfortable issue.

Phyllis is a different presence altogether. If Connie believes that the way to a better world is through struggle, Phyllis, just as doggedly, adheres to a doctrine of acceptance and love. She says, "I'd rather not fight. I'd rather make love. I have to touch hundreds, thousands of people, and I don't think I want to touch them with a sword. It's all in line with my renaissance of loving you so you can love me back. No, let me rephrase that. I don't love you so I can get love back. I love you because it makes me feel good. Is that corny?"

The "renaissance" refers to Phyllis's very personal struggle with breast cancer. Five years ago she had surgery, "and I changed my whole way of living. I never once said, 'Why me?' Who should it be? You? I wasn't being punished. There was no God up there doing bad things to me for doing bad things. So I decided that part of helping me was loving you. I am taking more control over my life, and this is the way I want to do it."

Connie and Phyllis have been together for ten years. They look enough alike to be sisters and don't at all mind being told so. They have matching haircuts, matching glasses. Both are wearing white pants and soft cotton shirts to be photographed, though Connie decides to put her union T-shirt on top. Where Connie is wiry, Phyllis is a little softer. They are playful and cuddly together, shy about a private language of affection, very much like girlfriends on a sleep-over. They maintain separate apartments, but spend most weekends together. That's because, as both admit, they share values, but not many interests. They enjoy socializing together with friends and family and the SAGE community, where Phyllis likes being allowed to flirt and Connie appreciates not being smothered. They are dedicated to SAGE and often find themselves working on

the same projects. They often do the *Times* crossword together, but Connie has her Union Square walking tours, her women's labor issues, and her house in the country, and Phyllis chooses to spend more time quietly alone. "I have people when I need or want them. And I've got things to do: my television, my VCR, my computer, my puzzles, trips to the library. There's always something. It's a good life," she says. "We respect each other's boundaries and space. We do have differences in some of our beliefs and some of our customs. But we agree on the important things. We agree on justice, social justice. We agree on politics. I have not had the active life she has had, but I understand what she's doing, what activism means to her."

Both women were brought up to find "a nice Jewish boy and get married." They both tried to be "appropriately" attracted to men, but both describe their first relationships with women as "revelations." Otherwise their lives played out very differently. Connie worked in the labor movement for forty years. She had lovers, long-term relationships with women who shared similar interests, who were part of a community she describes as "politically aware." "We would get together and talk about the war in Vietnam or whatever was happening then. We didn't talk very much about being lesbians. We were lesbians who had other lives and passions and concerns." She only came out at work, tentatively, in the eighties. "I had a sense that, if you're in any kind of a male-dominated world, it's harder, because if there are men there who oppose the rise of women, this is just going to be one other piece of ammunition for them." She is equally protective of historical figures, women whose lives she has researched for her labor history classes and the gay labor archive she would like to leave behind. She is reluctant to share publicly any of the work she has done because she doesn't want to "out" any "sisters," even those long dead. She respects their privacy

and fears that the information would be used to dismiss their accomplishments. "I'm never going to give them the satisfaction of saying, 'I always knew she was a dyke.'" Winding through her stories of commitments to women and to work is a thread of sadness and loss. Keeping her best-loved communities separate made it harder for her to be whole, or wholly visible, in any.

Phyllis left her hometown at thirty-four, with her first real love, and spent the next sixteen years with a woman who was terrified of exposure. They lived first in a small apartment near Rutgers where Phyllis pursued a degree in accounting. There was only one bed. No way to hide who slept where, so no entertaining. In fact, her partner preferred that she not even socialize with her fellow students. After Phyllis graduated, they built a house in rural Pennsylvania and went into business together. Their lives became even more insular and isolated, defined by the secret they shared. Phyllis was fifty when she managed to peck her way out of that egg. She came to "the big city," and someone told her about SAGE.

Given the absolutely closeted life she had been leading, it is not too surprising that she "said maybe three words in the first two years" of rap group participation. But as she sat listening to other women's stories, she decided that her silence "wasn't fair" to the group or to herself. "One day, I said, 'You know you're sitting in this group, everybody's speaking from their heart and you're saying nothing. You've got to stop this stuff. You're a person.' So I pushed myself. I got involved. I got so involved, I forgot myself, and I found myself talking and saying and doing. That's what SAGE did for me." She discovered that she makes friends easily. Connie was one of the friends she made.

Connie is retired now and recently celebrated her seventieth birthday. Her friends were asked not to bring presents but to make donations

either to SAGE or to the Wagner Labor Archives, "where my soul is, my papers, and where my gay and labor history will be." It was a sweet moment for her. In one room she brought together lovers and friends, colleagues from the many different eras and corners of her life. She felt seen and loved and proud. But if retirement has finally allowed her to blend her separate communities, it has also left a painful void. She gets joy from making waves. She wants to make waves again. She wants to feel useful.

Phyllis has also recently retired, but, unlike Connie, she finds the placidity her new life affords rather lovely. At five years, the medical establishment considers her a survivor. And then she has this to say about waves: "I've matured, and I don't need to strive for the same things anymore. I'm glad I'm not young. I don't want to have to go through all that again. This is the best that it gets for me. I know it won't stay this way, because things happen, but I'd like to preserve the status quo. I don't make waves. My world is happy. Am I stressing that too much?"

Connie and Phyllis both led compartmentalized lives. The ways in which that imprinted sometimes seems to exaggerate their similarities, sometimes their differences. Either way, they have reached this moment of reckoning together, with their very different rhythms, but at the same time.

Robert

At eighteen, Robert moved out of his parents' home. He got himself a job and an apartment. The apartment was only big enough for the bed and a nightstand, but it afforded him the privacy and independence he suspected he might need to look for life on his own terms. He wasn't exactly sure what that might mean, but he was sure he didn't want anyone one else telling him where to look.

He started with a place on Amsterdam Avenue. "The building I think is gone now, but it was a bar. I think it was between 1947 and 1948, if I'm not mistaken, and I met my first friend there. He was a little older than I am. But he died in 1953. He was in a car accident. We were together maybe about five years. That took a lot out of me because he was more than a friend to me. He was a companion. He's the only one I ever took home to meet my family. So after he died, I never bothered to . . . I've met people, but it isn't that way. So I've lived alone since then. I've had so many other things to do. I got into SAGE, and then there were so many other organizations that I got into that I never had time for anything else. And I'm always busy."

Robert is sixty-five now, but looks almost boyish. He has muscular arms, but can flick out a wrist like a runway model. He waits for me on

the stoop, dressed in Pride: T-shirt, cap, and necklaces. He is the superin-
tendent of the building on West 137th Street where he lives alone with
his dog and years of accumulated gay memorabilia. His small ground-
floor apartment is dark. Robert lives surrounded by proof of his connec-
tions to the world, and there is barely room for the two chairs where
we sit facing each other. He digs immediately for a prize possession, a
plaque that reads "For tireless efforts and contributions in making Gay
and Lesbian Pride Weekend such a success." The story of the fancy din-
ner and the standing ovation brings tears to his eyes. In ways that family
functions for many people, SAGE and other gay and lesbian service orga-
nizations have offered him a place "where you can go and feel comfort-
able, where you can talk about your problems and socialize for a few
hours, where you feel like you are wanted and you aren't shunned by
anybody."

Robert has tasted the alternative, and it was bitter. When he needed
help after his friend died, he tried the available social service routes. It
was a disaster. "You could be running all over New York City trying to
get help because the people at that time did not know how to deal with
gay and lesbian issues. They were married people. They would just shift
you to another agency. If you went to the Department of Health with a
problem, they'd dump you on Youth Services. Youth Services? You're too
old. We'll send you to Adult Services. I don't care how bad a problem
you had, if someone, if your partner died, there were no bereavement
services. You all went to the funeral, and you gave this person your
deepest sympathies, but there was no place for this person to go. If this
person got depressed afterwards because he was in this apartment by
himself, letting everything go, he depended on friends. If you didn't
have a lot of good friends, you were just out of luck—not like now,
when he can talk out his problems with people who are trained to deal

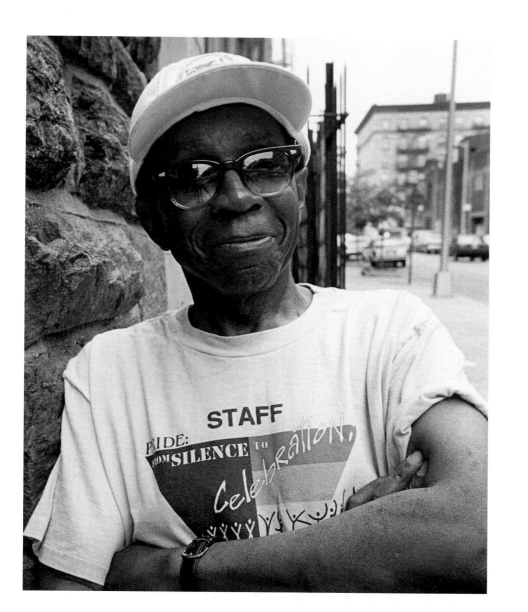

with them. Then there was no one to help you. If you had a friend that you could depend on, that's how you got by. That's how I got by."

From Robert's point of view, however, there has been a negative side to all this new support and visibility. He believes that in many ways things have gotten worse, not better, for gay people in the city. During the war years, and for a while after, he found work easily with large employers who hired gays and lesbians because they expected them to be "no trouble." "New York was then more industrial, in the forties, and fifties, up into the sixties: big laundries, coal yards, factories. You could be as gay as a fruitcake and work in a big laundry, in a hotel, in a hospital, because nobody cared. And you could tell by the way they were acting that they were gay. Some of the girls used to sit there at lunchtime making little doilies! They called themselves girls then. And in many cases, they hired them because they knew that they would do the work and no problems."

Robert is very clear about what lies behind this change: jealousy. "I don't have to go out and buy a coat for a child. I go out and buy something for myself to wear. They have to economize because they're running a family, and they look at it as if you, as a gay or lesbian person, have created this problem for them. I think that they think that we're just out every night carousing or that we're traveling all over the world. They don't realize that we have responsibilities, too. We pay rent, we pay light and gas, we pay telephone, insurance, medical bills. . . . So they use this gay and lesbian situation to blame us for all their problems."

Robert claims to have no idea why he chose never to risk another relationship after his friend died. He does not want to think about it, or talk about it. What he very much enjoys talking about is his active participation in gay issues and events. For ten years, he has helped organize dances and marches through Heritage of Pride. He boasts membership in

SAGE, Gay Men of African Descent, the Gay and Lesbian Independent Democrats, the DC37 Gay and Lesbian Issues Committee, and the Coalition for Lesbian and Gay City Employees. He even patronizes establishments because they are listed in the Gay Yellow Pages. There is satisfaction in his voice as he ticks off the list of organizations and reminds me "There's a lot of work there to be done. And that's a big help to the gay community." Like the plaque says, he is a tireless worker.

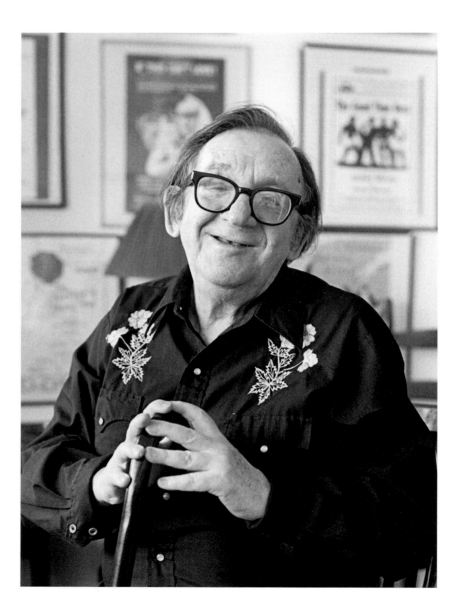

Sidney

Imagine an air raid drill, 1941, Pittsburgh. All the kids have been corralled into the school basement, squatting against the walls, masking anxiety with noisy bravado. The teachers are struggling to maintain order. To that end, Sidney is instructed to recite a poem. Sidney is the "sissy boy" in the class, delicately Jewish in a world of "tough young Polish kids." Sidney chooses "Little Boy Blue," a Victorian poem about a little boy who kisses his toy dog and tin soldier goodnight and then dies in his sleep. The toys gather dust in the chair where he left them, eternally loyal, awaiting his return. It is perhaps not the best choice for his audience. The kids dub him "Blue Boy, Jew Boy."

Now, Sidney perches on the edge of his chair while he tells his stories. He is a playwright and an actor, and when he is talking about events in his life, he can't help injecting plot synopses of his plays. It is hard to distinguish the scenes he has written from those he has lived. He is playing all the parts now, describing the shape of his memories. His face and voice morph from one character to the next. His hands are extravagant. Realities blend. He mixes it all up, with delight and energy. It is his turn to deliver all the best lines.

Sidney talks about his plays the way some people talk about their

children. The wall behind him is covered with production posters and stills from his performances. He fell in love with the theater when he was very young; he began acting at eleven, and his first play was produced when he was seventeen, in 1946. The stage gave him a chance to explore and express himself. It also introduced him to a world in which homosexuality was treated casually. "In writing, in plays and stuff, homosexuality is so dramatic. But it's really very small and simple. I remember Walter taking me home after a rehearsal. And there were Charles and Walter cooking, you know, in Pittsburgh, in this apartment together, with one bed."

Sidney was born into a home with five sisters and a Romanian mother and grandmother. He was very much the baby. There were some much older brothers, and a father, "a mystery figure who came in and slept with my mother every 6 or 7 months." But "by the time I came around, the house was filled with women." Sidney suspects that the first eight months of his life in the womb he was female, too. That would explain a lot: his delicate hands, soft skin, and the male privilege in his mother's house that somehow never applied to him. By the time he was fourteen, Sidney says, he "knew." But "I just wanted to have fun. I'd French kiss Dolores and touch her little titties, and then I'd go off to the park and find a man."

One night, shortly after his first play was produced, two big Irish guys picked him up. They turned out to be vice cops. The theater that had protected and indulged him had also given him visibility. "I wasn't just John Doe. I was Sidney Morris, assistant director of *The Hebrew Y*. I was Sidney Morris, star of community theater, who had just appeared at the Pittsburgh Playhouse. It was in all the newspapers. I was humiliated. I've never really recovered. I still have trouble trusting people." Sidney skipped town after a long and mean-spirited trial.

Yet, for all his self-proclaimed distrust of people, Sidney sought safety and security in relationships; first ten years with David, his "youthful passion," and then with René, a Frenchman whose deliciously "dominating" affect masked his haunted memories of the World War II trenches. René was afraid to live alone. His invitation to "come for the weekend" the night they met turned into thirty years. The way Sidney tells it, the years with René were high energy, high volume, high drama. "When I think of the musicals we saw, the movies, the plays, the books that we shared, the places we went. I had more fun with René than with anyone. I wish it to all couples. But we wanted too much. We expected too much of each other. We were always on the verge of leaving, knowing we'd never leave."

If the companionship was exquisite, it was a relationship that quickly outgrew lust. "When I was no longer that pretty femme boy that he picked up and promised never to let go, and when he was no longer that crazy, manic Frenchman, it was easier to go out of the house and find someone who would let us play the roles we wanted to play. If you need a man in your life," says Sidney philosophically, "you're going to learn to keep him. We always came home, but if you're stuck on role playing, then you get in trouble as you age."

Sidney had thirty plays produced, "professional runs, first-class productions," but when asked if he made a living with his writing, Sidney guffaws. "No, I did not make a living. I would not be living here if I did. I would be living on Gay Street in the Village with a little courtyard." With degrees in education and his expertise in theater, Sidney became a recreation group leader, using theater to communicate with children, sick people, and the elderly. He used the same skills in service to gay solidarity. "Those of us who knew that being a homosexual was more than dick were getting together, preparing environments for gay men and

women. Men were talking to each other. Men were supporting one another. Men would sit in the same room with men they weren't attracted to for two or three hours. So when this thing came, and there was this need, it was kind of in place."

"This thing" of course was AIDS, and the "it" was the political muscle that came out of the consciousness-raising groups of the seventies, ready to be flexed when the epidemic hit. The bonds of community were inadequate to the ferocity of the epidemic, and the retributive homophobia it engendered. Nonetheless, Sidney says, "I don't think those of us who survived would have survived if we hadn't been preparing." He is one of the people responsible for the Gay Men's Health Crisis, for SAGE. "And I'm one of the people who finally got the *Village Voice* to put the word 'gay' in." Most of all, "we made gay theater. And we made it at a time when there was one gay publication to come and review you. We made it at a time when straight actors were afraid to play gay roles. We made it in a very, very strange time."

All of those organizations, the support they offered and the political clout they wielded, have made a huge difference to him and to others, but Sidney is not optimistic. He believes there is a second wave of the disease coming and that the community has forgotten how to organize. "We are not going to have the spokesmen that we had. Gay men are tired of it, don't want to talk about it, want to believe it's over. And I think that instead of society becoming more compassionate and understanding, it's going to go crazy."

Sidney has had more time to think about that than most. On New Year's Eve, '83, he decided he knew he was positive. Four years later, after he had become symptomatic, a test confirmed what he already knew. There is both bitterness and a hard-earned self-knowledge when he talks about how his diagnosis drew him closer to the AIDS community. There

were so many people dying around him, and now he says that he "stupidly walked right into the ovens"—the AIDS unit at Cabrini Hospital, where he became a patient ombudsman. "I'm not sure what called to me to do it. I thought that by embracing death, being near it, I could come to the kind of acceptance I saw in other people. I've come up empty. I try to think of death like chocolate pudding, tell myself I'd love to put my head into that sweet chocolate pudding. But, in the long run it was a mistake because I've come up empty. I'm terrified of dying." Still, he adds, "I haven't gone over the wall yet. It's close. I'm in excruciating pain twenty-four hours a day. And the medication is just horrendous. I'm halfway through a new play, and I can't really concentrate. I'm tired of it. I'm tired of the disease. And I'm also a little guilty of getting attention because of it. I wish we were talking about one of my plays."

Sidney is writing another play, dealing with internalized homophobia. It's called "Doin' the Nasty" and he says that only someone who's seen seventy could write it. "I've been through a lot, as a Jew, as a man in America, as a gay man in America, as an effeminate child in America." Sidney gestures again to the wall of faces behind him and speaks with infinite love about the beautiful young men who were his stars. Then, with a sadness as huge as his love, he adds, "I won't tell you which of these children I sat with. I won't tell you who of these kids I held in my arms." He says he has buried close to two hundred. And he is now so sick himself, and there is so much left to do, so much still unsaid. "We, in this community, have a gift of making people feel good. We have a gift of making people look into themselves. We have a gift of making them lie down and shut up. We have this gift of pleasure. I'm so sorry for the world not to know how beautiful we are."

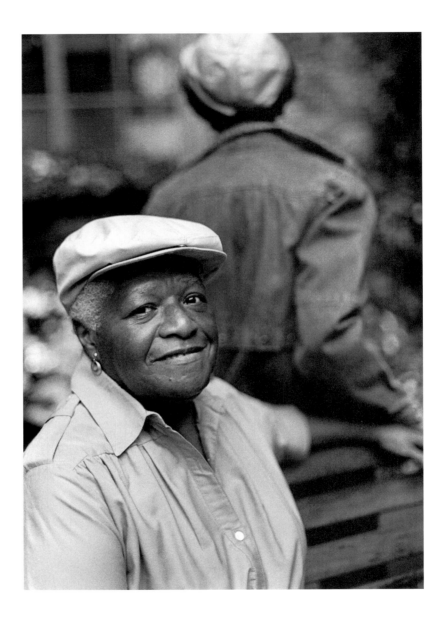

Eunice and Rose*

Eunice was fifteen when she first fell in love. She invited her girlfriend to move into her mother's home, and they lived there together for the next ten years. Eunice's mother, Maude, loved children. She created a warm and lively environment where the door was always open and any child was welcome—for whatever reason. Maude would pay a quiet visit to a newcomer's home to assure them that their child would be well cared for. Eunice remembers that at one time there were nine children in residence, and they called themselves a family.

Maude wasn't just openhanded. She was open-minded. When two of her daughters turned out to be lesbians, she drew on her Creole heritage to support them. She explained to them that "people do what is traditional," and in her tradition, West Indian tradition, it was "no big deal" for women, or communities of women, to live together. And she taught them, by story and by example, that in Creole culture women are expected to have a "macomé," "a special girlfriend with whom you can share everything." Eunice remembers Maude describing the relationship as very close, though not necessarily sexual. "But if you're married, even your husband knows better than to interfere. Nobody crosses between

<hr>

*"Rose" would prefer that her real name not be used.

you and your macomé." Maude gave her children a precious gift: acceptance. Eunice says it's "lucky" if your family accepts who you are. "If you have a problem with your family, then it's your problem, but if outside people have a problem with you, it's theirs."

Eunice is seventy now. I suspect she moves a little slower than she used to, but she leans into her walk, following her chin, determined, directed, and apparently unstoppable. She is passionate, articulate, and I can't imagine being on the other side of an argument and having an easy time. Not because she steamrolls. Eunice listens carefully, a talent well developed through years of standing respectfully in front of boundary-testing sixth graders. She was an elementary school teacher for most of her life and an activist both within the school system and without. She fought for College #7, which became Medgar Evers Community College, for bilingual education, for open enrollment. And she was caught up in the heady thrill of the civil rights movement. "All of that was so exciting. There was so much going on, and people really galvanized each other. But," she says wistfully, "we went home. We thought it was all done, but it wasn't. It was just beginning really. And that was the worst thing we could have done."

Eunice has had to find other outlets for her energy. She went back to college when she was fifty because she thought it would be interesting to work with older people for a change. One of the available research topics in a human resources class was aging homosexuals. Eunice took it because she dreaded having to listen to what one of her other classmates might produce. Her research led her to SAGE. She and her sister Hilda joined the organization, where they became known as "the sisters." And that's where she met Rose.

Next to Eunice, Rose is like a bird, delicate and skittish. She is shy, small, a little dreamy, and very definitely noncommittal. She elevates

evasion to an art form, and Eunice says "she wrote the book on closets." Ask her if she thinks of herself as a lesbian, and she might say she doesn't deny admiring women. But she will quickly point out that it would be presumptuous to assume that admiration is the same as love. How would she characterize her relationship with Eunice? Well, she would rather not say. "There are Platonic friendships and then there are friendships that are a little more than Platonic." She won't call it love. No, she has never been in a committed relationship before. No, she has never lived with anyone before, and she would have me understand that she is only living with Eunice now because she was evicted from her apartment. Does this relationship make her happy? "Well," she says, with a big complicit smile, "Well, it doesn't make me happy, and it doesn't make me sad. It's not unpleasant."

Eunice is sitting back in her chair, thoroughly amused at how I have been lured into the game. She says, "It used to drive me crazy when I first met her. She was always saying she'd put her toe in, but never her foot. And especially nothing else. Always just on the edge of everything. Me, I'm in over my head immediately. I had an out life, and she had a very sequestered kind of existence. But I think she was just sitting in the closet waiting for me to come and drag her out kicking and screaming. And I want you to know she kicks and screams a lot!"

Eunice is clearly both charmed and challenged by Rose's elusive stubbornness. They tell a story on themselves that goes, I think, to the heart of their relationship. Eunice considers herself to be the travel expert. She knows the best way to get places, and Rose is willing to follow her lead—unless and until Eunice gets a tad too bossy. And then Rose will simply fail to get off a train. The doors will close, and Eunice will find herself and her expertise on the other side of the train window: "I'm looking at her and she's sitting there smugly going to some other station, I don't

know where, and I have to rush home and wait for her to call so I can tell her how to get home." It has apparently happened more than once, and now the mere threat is enough to reconfigure a situation and send them into gales of laughter.

In 1989 Hilda told Eunice that she had found a lump in her breast, but she refused to do anything about it. She was terrified of male doctors, and Eunice had to cajole her into a free screening at Memorial Hospital by saying she wanted company while she got herself tested. The two sisters emerged with matching diagnoses, matching terror, and polarized plans for managing their individual crises. Eunice had a mastectomy in 1990 and considers herself a survivor. Hilda refused all conversation and all treatment. She died two years ago.

Eunice now puts her compassion and her hard-won wisdom to work for women battling the disease. She does counseling and consulting for SHARE, the American Cancer Society, and Cancer Care, and she started her own support group for lesbians at the Center. Her dream is to establish a health clinic staffed by lesbian doctors. "It's one of my soapbox issues. We need it. We need a lesbian clinic so that the women that I can't get to take examinations will come. Hilda was afraid of male doctors. She trusted lesbians. If there was a lesbian clinic, she would have gone. Lesbians have to know that it's a safe place for them, and they'll come."

Eunice had a saying: "I was going somewhere and I would take company, but I wasn't going anywhere else." Sounds a bit like the travel director, like someone who has put career before relationships, proudly, and like someone who makes things happen in the world. But this relationship with Rose may have surprised her. It is not surprising that Eunice would have connected with another breast cancer survivor, and Rose is that. But it is surprising and delightful to be able to blend companionship and career, to have a partner who is also a teammate and a

colleague, committed, for her own reasons, to the "somewhere" that Eunice has now chosen. They work well together, and they are excellent company for each other. They have tactics for keeping it that way. Just mention "fussing," and they are both laughing. And whether or not Eunice manages to drag Rose out of her closet is not a pressing question. Eunice suspects it is a form of flirtation. I suspect she is right.

Nick and Tony

It would feel artificial to start anywhere else than with numbers. The numbers in this particular story insist on staying in high relief. Nick is ninety-four. Tony is fifty-three. They exchanged rings and found their sunny apartment with its view of Central Park twenty-one years ago. They enjoy walking in the park together, and when they walk they are always touching. It doesn't seem to be about support. Nick wears his ninety-four years with an ease that is inspirational, and, for such a gentle man, he can be quite brusque about what he perceives to be unnecessary, or even intrusive, assistance. He does not appear to have slowed down much, and though Tony's hand is often under Nick's elbow in what might look like an attempt to keep him from toppling, I suspect it is probably more about holding on. They wear their matching rings on their right hands for no other reason than that Tony's father was a right-handed construction worker who wore his wedding ring on his right hand. Nick's father was an entrepreneurial spirit who traveled between Italy and the States developing small shoeshine businesses, selling them, starting over. It might have been the adventure that made him move so much. It might also have been the men he found fascinating, and irresistible. Nick's mother would be left on one side of the Atlantic or the

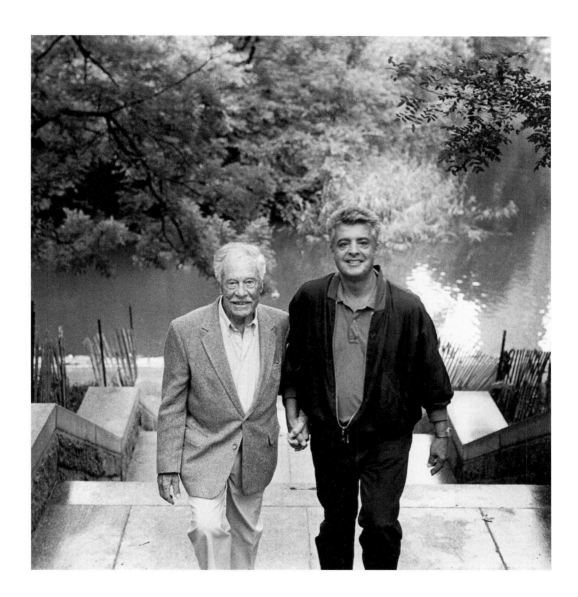

other, to fend for herself and her children until he sent for her. He always did, but Nick was always aware of his father's other interests. His mother could only contain her opinions and feelings up to a point. Then everyone would hear about "that Englishman upstairs"—or whoever the latest one was. Because of her husband's rambling ways, some of her children were born in the States, some in Italy. Nick was born in Italy in 1903. His mother was a midwife, and delivered him herself, alone. She was not afraid of being alone. She was a resourceful woman. She made wine in the basement throughout Prohibition to support the family and help put Nick through medical school.

It was when Nick was at Middlesex College of Medicine and Surgery, which later became Brandeis University in Boston, that he understood that he was a gay man. He had had some prior experiences with men, more with women, and as he recalls, "I had a job deciding, until I met Bob." But with Bob he fell in love. Nick remembers the night in 1933. Their eyes met as he "walked down the aisle" in a theater. That was it. They met after the show, spent the night together and the next forty-two years. Bob was an adagio dancer. He was handsome, elegant, made friends easily, and knew the ways of the gay world. They shared an apartment on Beacon Hill, the center of gay life in Boston in the thirties, and when Nick completed his internship in psychiatry, they moved to New York where he would do his residency.

Nick had some trouble keeping jobs. Three times he had to switch hospitals because someone was uncomfortable about the fact that he was living with another man. When the war began, Bob was drafted and Nick enlisted. Nick is proud of his record of sorting out those soldiers truly afflicted with battle-related illnesses from those whose commanding officers had decided their homosexuality made them discharge material. Those who wanted to go back to the front, to avoid being dis-

charged with prejudice, were given a clean bill of health by Nick. For obvious personal reasons, Nick was fascinated by homosexuality, and it was while he was in the army that he began the practice of including questions about sexual preference in his intake interviews. It was a practice he would continue throughout his career, a personal research project that has led him to the absolute conviction that homosexuality is a genetically inherited trait.

Nick denies being a crusader of any kind, but while in the army and in his later practice, he often found himself defending the "normalcy" of homosexuals. He says he "came out" at staff meetings frequently with the opinion that "These people are not sick. They are well. They need understanding." But when asked if he thought his standard-bearing might have aroused suspicion about his own proclivities, Nick bristles and claims that he "was never accused of being gay." The climate of the times shows through in his choice of words.

Nick was appointed director of mental health in Nassau County and had responsibility for supervising twenty-eight clinics by 1945, when Tony celebrated his first birthday in a tightly knit Italian working-class family in Connecticut. He says he was popular growing up, "dated, the whole thing." But after high school, he went into the seminary to study for the priesthood and "that's when all the feelings surfaced." He began to have strong sexual attractions to men and, in such close contact with an all-male community, those feelings became intolerable. He withdrew and went to Marist College. There, he finally connected with another gay man, a fellow student, who became the friend and soulmate he so desperately needed at the time. They were never lovers, but together they talked through Tony's coming out.

Nick and Tony met on Fire Island in 1976. Nick was seventy-three and Tony was thirty-two. Bob had died the year before, and Nick was

forlorn. He describes his behavior at the time as promiscuous, a frantic search to replace a relationship that had been sustaining. Shortly after they met, Tony remembers the sweet seduction of being handed a poem on the island ferry, a poem called "The Key Is Found." Tony is someone who cries easily, succumbs to emotions. This is a set-up. He reads from the poem haltingly, with heartfelt pride and some considerable effort:

> The key was rusty with love forlorn
> But used again a new love was born.
> You are the love, I've known it from the start.
> You found the key that has unlocked my heart.

Tony says he was always attracted to men with gray hair. "My whole gay life, it was a thing for me." Nick is admittedly a "father figure," and Tony treats him with a deference befitting that image. Nick is also the "caring person" on whom Tony chooses to model himself. Tony finds it "amazing" that Nick continues to see old patients and charges no fees. People from all parts of their lives, including Tony's family, bring their problems to Nick. But Tony finds it equally amazing that he himself engenders a similar admiration and devotion in his students. He has been a teacher all his life, first elementary school, and now with junior high school children in the cancer wards at Memorial Hospital. He is immensely moved by the affections of the children he has come to think of as his own. If there is one regret, "one thing missing" in his life with Nick, it is "the chance to have a kid and raise a kid." He wistfully acknowledges "that at Nick's age—and at my age—it would be very difficult."

With that form of "giving back" closed to him, he has nonetheless managed to parlay his mentor's example into a sort of second career, also about giving back. He is a star-quality fund-raiser for AIDS and gay

rights causes. He loves the feeling of doing good work—and he does love a party. He loves the organizing, the event itself, and especially the reaped rewards. Their Fire Island community is the perfect place to indulge. His enthusiasm borders on an exuberance that I suspect is contagious. And it is something they enjoy doing together. In the good old days, they would sometimes make five events in a single day. But Nick is slowing down a little. Sometimes now he just makes it to the dinner.

If Tony has managed to pick the lock on Nick's heart, he has had a harder time with his closet. They grew up in different times. Nick always referred to Bob as his nephew, even on Fire Island, which was hardly what Tony would call a "closety" community. Bob and Nick had double-dated with women throughout their many years together, but when Nick tried it with Tony, it simply wasn't going to fly. Their first New Year's Eve together, Nick got him a date. "I'm with my lover on New Year's Eve," remembers Tony, "and I can't even kiss him. I said, 'I'll never do this again.'"

At Tony's insistence, they are active and visible members of SAGE. Nick has written his memoirs in the last few years, entitled *As If by Choice,* and he is looking for a publisher. He claims he is no longer worried about criticism: "I didn't want to be chastised for being something which I felt was perfectly OK." That may be the doctor speaking, and old habits die hard. Even though Nick acknowledges that things are a little different now, he still suspects it is safer to be quiet. How quiet? "What do you think the doormen think?" I ask. Nick hesitates before answering, "We don't know." "They know, Nick," says Tony gently. "Everyone knows."

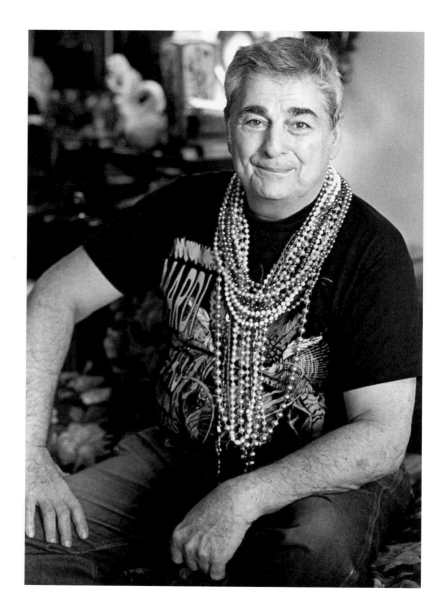

Larry

Larry remembers with gratitude that it was a long weekend, Rosh Hashanah, when Paul died. He would have both Friday and Monday off. Otherwise, he suspects he might not have made it. As it was, Larry showed up at Sheepshead Bay High School on Tuesday morning, a stunned and brokenhearted man, trying desperately to hold it together for a class full of teenagers who could only know that he had lost a friend.

Larry was a high school teacher. Paul was an artist. For thirty-three years, they shared a life rich in common interests and concerns. Larry remembers that, every night at 10 o'clock, Paul would interrupt him with a cup of tea and an invitation to put his schoolwork down and talk about their respective days. After Paul's death, Larry found he couldn't keep his grief out of the classroom. He retired, joined the fifties rap group at SAGE, and proceeded, in short order, to proposition every man in the group with some version of "Please come live with me. We can be lovers, or not, that's up to you, but I just can't make it on my own. I am used to living with a partner. This is too much pain." One after another, they turned him down, but as a group they orchestrated a nightly phone call. One or another of them would call and say, "10 o'clock, Larry. Time

to put it all away. Make yourself a cup of tea, and let's talk about our days."

Larry revived. He started to socialize, made new friends, made plans to travel. One night, on the way home from the opera, he found himself in the men's room of the PATH train. At the urinal next to him was "a beautiful young Black man." Larry dug up some tawdry line like "Haven't seen anything that big since before I was married." The young man smiled and asked about his wife. Larry said, "Not a wife, a husband," and explained that Paul was recently dead. The young man said he had just lost someone, too. They went for coffee and talk. "He was the sweetest thing you ever met. And his name is Ramón. Of course, he told me all kinds of lies, you know. It was like being in a bar. He had an Italian father and a Black mother. Well, he's got a Jamaican father. His parents are beautiful people, and he doesn't have to lie. He's got a nice family. But, you know, he wanted to sound glamorous. At that time, I was sixty-two and he was twenty-seven. Almost half my age. I said, 'Are you willing to come and live with me someday?' And he said, 'Can I move in now?' I said, 'Bring everything you've got.' And he moved in. He's been here since 1987. August of '97 will be ten years. He's making my life so happy. That's the way it should be. He's my companion. He's different from Paul. Paul was very much secure, very much able to make decisions by himself. Ramón needs me. And it's nice to feel needed. Especially when you reach my age."

Larry didn't know that he was homosexual until he was in his twenties. In the middle of his sophomore year in college, he was pulled out of school and sent to Fort Dix. He spent four years in the army. It was the early forties, and the way he remembers it, "Nobody asked you anything! Oh, sure, you could get out by saying you were a fairy, but nobody wanted to admit that. That was a very bad time for being a fairy.

Outside the army. Inside the army, it didn't matter. I don't remember anybody during the war being condemned for being a homosexual. During the war they needed every man. And, of course, God bless the WAC's and the WAF's. They were wonderful. But the army made a gay man out of me. When I read in the newspapers about how they don't want gay men in the army, I laugh! Because I was thrown in with all these wonderful guys, and finally! finally! I fell in love with a man."

It took about a month for the idea that he was making love to a man to become disturbing. He remembered having seen cheap books with medical-sounding titles at Woolworth's and happened upon a book called *Psychiatry and Mental Health*. "I still own that book. It was written by James Rathbone Oliver, M.D., an Episcopal priest. And he says, 'To social workers and priests who read this: If you find you have a homoerotic congregationalist—someone comes to you and says he loves someone of the same sex—do not gasp, scream and call him names. God made all of us. God does not make mistakes. And certainly not that many! Therefore, assure them that love is the answer to all their problems, no matter who they love.' So I said to myself, 'I'm not a mistake of God because God doesn't make mistakes.' And from that moment on, I've never worried about being homosexual. It was one of the lucky things in my life, one of the times when I felt I had a gay angel up in heaven taking care of me. A Fairy Godmother."

Larry felt married to Paul, and, though nothing was ever explicit, the two attended functions, both public and private, as a couple. Larry's mother "never said anything," but "entertained Paul as if he were my wife." At school, he made no particular effort to hide the fact that he was gay, and he felt accepted because he was "a good teacher." He took advantage of his position as role model to challenge his students' discomfort with difference. "Some kid in one of my honor classes would say,

'We don't want so and so. He's a faggot!' I'd say, 'You are supposed to be the smartest kids in school. That's why you're called honor students. If anything, you should be more tolerant. You're oddities yourselves, you're so smart. Why do you condemn somebody else who's different?'"

Larry has a substantial collection of opinions and an ego to match. He was in the theater before he started teaching and developed a rousing delivery. He also tends to the flamboyant. Paul assumed the job of keeping the lid on. He'd say, "No, you're a teacher. You've got to be dignified. You know you've got to be dignified." But Paul died in 1986. Larry now considers himself an activist. He works for PrimeTimers. Last year, he stopped the privatization of his Mitchell-Lama Co-op. And he now leads a discussion group at SAGE. He thinks of his work at SAGE as "giving back" to the "family" that helped him learn to live with the loss of Paul.

Interestingly, in his new role as activist, one of the first communities Larry challenged was his own newfound "family." At the Halloween Parade, after Paul's death, he met a man from his discussion group dressed as a woman. He was with three other men dressed as women. "I had such a good time with them. They were funny, delightful, and they were so warm. They made wonderful remarks about people going by, you know, bitchy. It was a delight. I had been frightened of transvestites until that moment. Now when I hear someone say they don't like transvestites, I say, 'Why? They have such a wonderful sense of humor. They can make your life very funny. You don't have to have sex with them, just have fun!' Old people, older gay men tend to put down certain groups. I don't know how many men in that group, even to this day, have a hang-up about something: people who use their hands too much, people who call you Mary or Susan. But, thank God, I'm beginning to lose all prejudices. I live with a Black man. That's one prejudice that, if I ever had it, is gone."

Larry

Larry is one of those people who can't be suppressed, one of those people who manage to keep their hearts open no matter what the Fates throw their way. Losing Paul would have destroyed a lot of people, but Larry is a bit like the phoenix. He says, almost ecstatically, "I have been so lucky. I suppose I should be waiting for the sword of Damocles to fall. No one can have all the good luck I've had in my life, and all the happiness. It's just wonderful. Where I get my biggest kick right now is coming out of SAGE or out of the [Gay and Lesbian] Center and seeing two young people with their arms around each other walking down the street. That, to me, is the joy."

Muriel and Deborah*

No one was surprised that Muriel's mother had had another vision. She had always used her "sight" to keep tabs on the family, and her visions had only gotten clearer with blindness and age. But for some time, the images of Muriel that had come to her had included someone else—clearly a lover, but also clearly a woman. She had never questioned her sight before, but how could this be her daughter, the "wild" one who had so many boyfriends growing up? How could this be the one who was married for a second time, the mother of her grandchildren? It made no sense. She kept trying for a clearer picture. It never occurred to her that the vision might be accurate.

For Muriel, falling in love with a woman was something she "should have" expected. Based on a belief that life is patterned in circles that ripple out from one into the next, and based on the belief that a mess in one circle is surely carried over into the next, Muriel should have known. She had made just such a mess. As a political activist in the seventies, Muriel had disrupted a radical women's group rather than come to terms with the lesbian among them. "She came out and I had a fit. I

*This piece is dedicated to Ingrid Washinawalok El-Issa, who was killed in 1999, fighting for the rights of Native peoples. "I never got to tell her how proud I was of her."

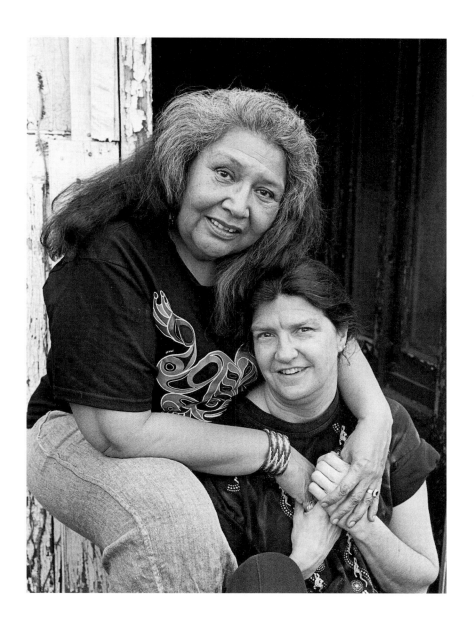

didn't want anything to do with her." It was deeply hurtful behavior.
There is a justice, if not inevitability, in the fact that Muriel's politics
now revolve around Two-Spirited people, and her life in the little yellow
house she calls "the res in Brooklyn" is a life she shares with a woman.
This is a clearer circle, but Muriel is still shamed by the memory of her
past behavior. "You have no idea how I carry that around."

Muriel's mother's people were Rappahannock who came north from
Virginia at the turn of the century. It was a time, Muriel insists, when "it
was better to be a black person than an Indian." They settled in the yel-
low house where her mother was born, and her aunts and uncles. Her
grandmother was a midwife, and "my sisters were born on the floor in
the back room." It was a woman's house, "a matriarchy," Muriel says,
but in the early days it was not a place in which Native history was nur-
tured. The family converted to Christianity. They sang hymns and when
Muriel's mother chose to marry a man who embraced his Native culture,
she forbade the speaking of "Indian" in the house.

It must have been terribly hard for Muriel's father. Eagle Eye was
Kuna, from the San Blas Islands off the coast of Panama. He was a proud
and charismatic man "with a big light, a good dancer and singer, and he
did beautiful beadwork." The son of independent sailors and fishermen,
he spent the Depression working as a sideshow Indian to support his
family. "Carnasie had a big side show. And Coney Island. That's how
they survived. That, and he made bathtub gin out of vanilla beans and
who knows what else. He would stand on the corner and sell it, head-
dress and all. My sisters were all ashamed to be Indian. They thought of
it as show-biz."

To her grandmother, Eagle Eye was "that savage" who never stopped
longing for home and who repeatedly tried to leave. But he was bound,
Muriel remembers, by the strength of her mother's medicine. "She want-

ed him and she called him. She didn't care how miserable he was."
When he went on a binge to numb his longing, "she would line the
children up at a quarter to every hour." Arms outstretched, with ritual
finger separations, the sisters would chant in unison: "Daddy, come
home! Daddy, come home! It just drove him nuttier—to have people
talking in your brain. You're crazy enough. You don't need that. She
made him crazy telling him where he had been and who he had been
with. She was a hard woman to lie to."

The years after the Depression brought an expanded sense of Native
pride into the yellow house. Other families who had left their ancestral
homes in search of economic opportunity were congregating in the
neighborhood, settling down and raising children. Now, there were al-
ways people in the house, family and extended family. Muriel, thirteen
years the baby, had a very different childhood than her sisters. "We, in
this house, learned many songs, from all different Native people that
came into our lives. My father and my uncles and these men would sing
back and forth, trade songs back and forth. With drums and pipes, and
at some point all of us young ones, started to really learn the songs and
we started to dance. They wanted to teach us, so we started to learn from
them, these Elders." Her father did all the beadwork on her first outfit.
"It was white with beads in the shape of diamonds. And the headband,
it had two American flags. Beautiful work." But she would not dance in
the Thanksgiving pageant at school, where the music teacher pounded
chords on the piano and insisted it was "Indian" music. "We were
brought up to know what we are. We are Kuna and Rappahannock. We
are Native people. I had all these things that nobody else had, and they
were mine. I used to think how fortunate I was to be born Indian."

The politics of the late sixties and seventies profoundly influenced
the directions Muriel would take. She was doing Broadway theater but

becoming increasingly frustrated. "Nobody was going to ask me to be Juliet. No one was going to ask me to be Liza Minelli. Or anything else, except a whore or a housewife or an Indian princess." She had "married an Indian man to have Indian kids," but the American Indian Movement, and the takeover of Alcatraz, the BIA building, and Wounded Knee radicalized her thinking. She began collaborating with an ethnically diverse group of feminists whose theater pieces spoke to the sameness of women's experience in different cultural contexts. "Women's Space" helped put her in touch with her feeling of "betrayal at the way Native men were approaching this revolution. The house was always full of activists, and these young men would talk about the 'Indian way.' The Indian way to them meant the worst things you could possibly do to women. I would listen to this and I would have to say, 'You know, you are talking to a woman who comes from a matriarchy. I was brought up to stand up for my rights. I'm really pissed off now, and I want you to clear the table.'" Muriel's marriage didn't last. But if that was a clearer circle, Muriel still had to deal with the mess she had made in Women's Space, "carrying on like a fool" when the lesbian in the group came out to her.

All that was twenty-five years ago. In the ensuing years, Muriel created Spiderwoman Theater, named for the Hopi goddess who gave weaving to the people. She calls their performances "story weaving" because they weave old stories and old truths together with the lived experiences of her contemporaries. Spiderwoman's stories are a revitalization of tribal traditions of respect for women and for "Two-Spirit" people. Two-Spirit, as Muriel describes it, is about possibility. "In yourself, you are male and female spirits, and it's your choice." Her love of ceremony, of women, and of Native culture, past and present, are woven together in this work. "It's all so connected. One circle goes into another."

The interconnecting circles of Muriel's life are apparent in the spaces

she creates around herself. Her mother is long gone, but Muriel still lives in the little yellow house, third generation under the same roof. Its rooms are crowded with a century of living, of inherited memories and memorabilia. For all her insistence that she is tired of being "puna," number 1, the one who takes care, she incants its history with not a little awe. It is both an honor and a responsibility to decide what is of value. Muriel has chosen carefully. In her backyard garden, in a Kuna T-shirt and surrounded by the same herbs her grandmother grew, Muriel drinks cappuccino with Deborah, the quiet woman who stagemanages all of her productions and has shared her life and her love for the past ten years. They play like puppies together. Muriel does most of the talking. She is a woman who takes up a lot of space, with a bright light, much, I imagine, like her father's. That is just fine with Deborah, who prefers silence and solitude and backstage responsibilities.

Of all the men and women in this book, Muriel's status as Elder is perhaps most literally recognized. At her first Two-Spirit gathering in the early nineties, she remembers a young man approaching her for advice—as an Elder. "I said, 'What do you mean, Elder?' See, I thought I was very glamorous. And of course, it turned out I was the oldest one there." The gatherings have meant a great deal to her. Rituals are shared, and stories, experiences, ideas, and addresses exchanged. Before she started going, Muriel remembers thinking that she was "the only Native American lesbian" in New York. "A lot of us came from communities of two. Now we have other people to talk to. Now we have a women's drum group. It is so important to talk to each other, just to be with other Two-Spirit people." And being an Elder has proven to have unexpected benefits. Muriel gets to be raunchy and wise and very visible. "I get to kick back my heels," she says, "in a way that I would not allow myself with white people."

Muriel is an Elder in another sense as well: she is a cultural archivist, a guardian of truths. "We are," she says, "finding our new history. We are making our new history." The little girl who wouldn't dance to the wrong music grew up to be a weaver of stories. The woman who once so adamantly rejected her lesbian friend grew up to be a lover of women and a creator of Two-Spirit community. Muriel laughs now, thinking back on it, "The circles always connect. If you have a lot of mess in one circle, you take a bit of it into the next. I should have known I was going to be a lesbian then."

James William*

James Wellington landed in Salem in 1632. He was a Loyalist, and during the war, the Revolutionary War that is, he and his family were forced to escape across the border to Halifax to protect their heritage. Over the ensuing generations, there was a slow migration of Wellingtons back across the border into the state of Maine, but the family brought their history and their pride with them, carefully wrapped, the family jewels. After almost four centuries, there is still "not a Roman among them." French was forbidden in the house. Occasionally a little Down East slips into James William Wellington's delivery, but for the most part, his speech patterns still pledge allegiance to the Crown. His lineage makes him proud, and he trots it out at every opportunity because he believes that others will share his pride. "Not very many New Yorkers have that background. It is quite an accomplishment."

On another level of reality, James was raised on a farm in a small town just south of the Canadian border. His mother had five sisters, his father, four, and he, three. The women were strong, proud, hard-working, and devoutly religious. It is not difficult to imagine the crush of

*The names have been changed in this piece to protect "James's" family.

their combined disdain for a boy too weak to wield his mother's ax, a boy who would rather play with his sisters' dolls than help his father work the farm.

Assigned the "women's work" of milking the cows, James protested their judgment in passive-aggressive ways. He hid the tools he couldn't handle to frustrate his father. He had to be fetched from school by his humiliated mother for failure to wear underwear. And one evening, he remembers, the entire family watched in horror from the porch as he led the cows in from the pasture, wagging his penis like a flag of defiance. An extravagant gesture of rebellion? Perhaps, but "maybe I just wanted to show them that I had masculinity, too."

His penis was perhaps the only thing that identified him as masculine. By the time he went to high school, kids were calling him "fairy" and physically tormenting him. The school insisted he be tested for his tantrums and aberrant behavior. There was talk of "queers" and "hermaphrodites," but then there was also talk about the French and the "Romans," and it was hard for him to grasp that the despised categories of otherness might include him. He did not realize he was a homosexual until he lost his virginity at the age of twenty-eight. In the meantime, in the confusing absence of a coherent identity, he set to finding ways of drawing attention to himself. He wore pink J. C. Penney pants to school.

Gender is still something James dresses in. It is something he parades, and it often attracts censure, even when put on in fun. I met him on a day when he had been pointedly asked to leave a clothing store. He had on silver lamé short shorts with matching silver high tops, a flashy red dye job, and, he recollects, "It was a very rouge-y day." He was hurt, but undeterred. "I dress to attract attention. Everybody sees me and says,

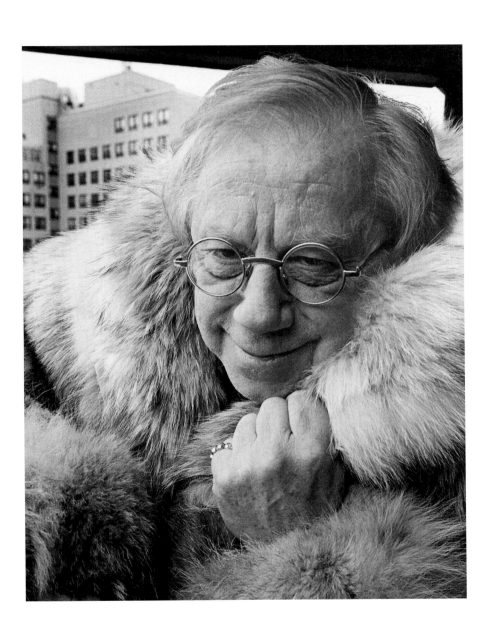

'What do you have on now? I've never seen you in that.' And I feel very noticed then."

James would be the first to admit that his aspirations to elegance were not always successful. "I had to be constantly careful about colors. I'm not artistically inclined to blend them entirely." Bobby helped, once they met in 1972. Hairdresser and antique dealer, he was, to James's mind, "an elegant gentleman. I like elegant gentlemen." They lived together for sixteen years, until Bobby died in 1988. "I thought Bobby would give me some of that, liking antiques and such. And he helped me to coordinate colors. Since he is a hairstylist, you know, he was very creative in that area. I'm much better than I used to be. I've toned down. But wearing pink pants in a country school. Wasn't that courageous!"

James passed the civil service exam in 1960 and for thirty-five years worked as a caseworker with the blind and the elderly. He loved his job because "they're so grateful for what you do, especially when they're helpless in a nursing home." After work, he often stayed to entertain. He is proud of his singing, and, of course, it affords an opportunity to dress for effect. In his tartans, he is quite the balladeer.

James attributes much of the abuse he experienced as a child to jealousy of his musical prowess. "I was a musician and the other ones weren't. I sang and they were very upset." He imagines people envy him his music, his name, his heritage, but perhaps especially his clothes. Clothes permit him to be whomever he is in the mood to be for however long it is amusing or safe to maintain that particular persona. And then he will change, chameleonlike, get out of the way of criticism, judgment. He will simply be someone else. In his plaid western shirt, he says, "I was real masculine today. I felt real masculine today." But he also

tells me about the full-length mink, and he dresses for the camera in a new coyote coat. As he snuggles into the soft fur, he is many things at once: adorable elf, flamboyant outlaw, James Wellington's aristocratic heir. He smiles at me, coyly insisting that "it's somewhat masculine, too, isn't it?"

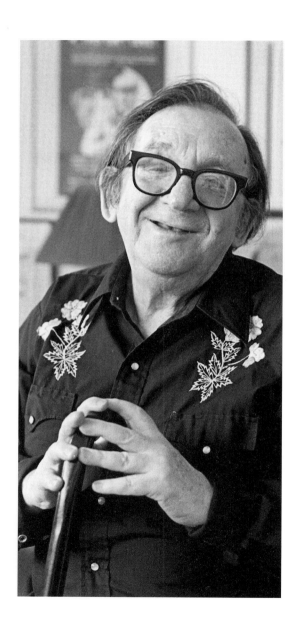

Penny Coleman is a writer and photographer living with her family in New York City.

Typeset in 9/14.5 Stone Serif
with Stone Sans display
Designed by Dennis Roberts
Composed by Jim Proefrock
at the University of Illinois Press
Manufactured by Friesens Corporation

University of Illinois Press
1325 South Oak Street
Champaign, IL 61820-6903
www.press.uillinois.edu